W9-ADS-361

DATE DUE

DEMCO, INC. 38-2931

KALAMAZOO VALLEY COMMUNITY COLLEGE
LEARNING RESOURCES CENTER
KALAMAZOO, MICHIGAN 49009

WITHDRAWN

Lewis W. Hine, 1936
by Sol Libsohn

TR
140
.H52
G82
1974
c.2

ICP Library of Photographers

Lewis W. Hine

1874–1940

TWO PERSPECTIVES
by Judith Mara Gutman

WITHDRAWN
KVCC KALAMAZOO VALLEY
COMMUNITY COLLEGE
LIBRARY

GROSSMAN PUBLISHERS
A Division of The Viking Press
New York 1974

OCT 18 1990

ICP LIBRARY OF PHOTOGRAPHERS

Series Editor
CORNELL CAPA

Series Associate Editor
BHUPENDRA KARIA

ICP—the International Fund for Concerned Photography, Inc.—is a nonprofit educational organization. Established in 1966 in memory of Werner Bischof, Robert Capa, and David Seymour—"Chim"—ICP seeks to encourage and assist photographers of all ages and nationalities who are vitally concerned with their world and times. It aims not only to find and help new talent but also to uncover and preserve forgotten archives, and to present such work to the public. Address: 275 Fifth Avenue, New York, N.Y. 10016.

Vol. 4: LEWIS W. HINE

Editors
CORNELL CAPA
JUDITH MARA GUTMAN
BHUPENDRA KARIA

Editorial Consultants
YVONNE KALMUS
ENID S. WINSLOW

Design
ARNOLD SKOLNICK

Copyright © 1974
by International Fund for Concerned Photography
Text copyright © 1967, 1974 by Judith Mara Gutman
All rights reserved
First published in 1974
in a hardbound and paperbound edition
by Grossman Publishers
625 Madison Avenue, New York, N.Y. 10022
Published simultaneously in Canada by
The Macmillan Company of Canada Limited
SBN 670-42742-x (hardbound)
670-42743-8 (paperbound)
Library of Congress catalogue card number: 72-11010
Printed in U.S.A.
by Rapoport Printing Corp., New York City
Photograph credits appear on page 84

ACKNOWLEDGMENTS
We appreciate and thank all those who extended themselves in the writing and editing of this book, especially Joseph D. Thomas of the audio-visual division of the National Archives for locating never-before-seen Hine photographs; Mickey Pallas of the Center for Photographic Arts, Ltd., Chicago, for lending original Hine prints; Thomas Barrow, formerly of the George Eastman House, Rochester, New York; Jerry Kearns of the Library of Congress, for personally helping to make material available; and Mayzette Stover, a friend of the Hine family, for putting us in touch with the community of people and ideas with which Hine lived.

Contents

"There were two things I wanted to do. I wanted to show the things that had to be corrected. I wanted to show the things that had to be appreciated." Thus did Hine define a half century ago what the "concerned photographer" was to be about. Unhappily, in his own time he found more "that had to be corrected" than the fulfillment of the other half of his wish.

Judith Mara Gutman's *Lewis W. Hine and the American Social Conscience*, published in 1967, was the first publication to present a comprehensive body of Hine's work. This volume offers her an opportunity to reassess Hine, and contains both her new and earlier thoughts.

The stated spiritual and visible photographic bonds connecting Hine with the present-day "concerned photographers" are obvious. However, there is a little-known historical fact connecting both. The first museum in New York City to give a posthumous retrospective of Hine's work, in 1940, was the Riverside Museum. Following that exhibit the museum did not present photography for almost thirty years. It is significant that its next photographic exhibit was "The Concerned Photographer" in October 1967.

The Riverside Museum permanently closed its doors in 1970. We wish to acknowledge our debt and express our thanks to the museum's founders, the family of Louis and Nettie Horch, for having recognized the artistic value of works which had great social importance at a time when not many museums were ready to do so.

Cornell Capa

Lewis W. Hine
and the
American Social Conscience

In 1908 Lewis Wickes Hine proudly announced himself a photographer and filed his first advertisement in *Charities and Commons* with twenty-two close lines of type. Within a year or two he opened a studio, employed a staff, catalogued his work, developed film for a newly conscious public, and made slides of the photographs he took for the National Child Labor Committee when he addressed its members at conferences in 1909, 1910, and the years following. By 1912 he ran a thick black question mark through the center of his advertisements: "Stereopticons? Call at 27 Grant Avenue, Lincoln Park, Yonkers, New York." By 1913 he prominently displayed a photograph in the center of his advertisement and recomposed the type and changed that photo for each weekly announcement in *Survey* magazine. In 1919, when he moved to Hastings-on-Hudson with his wife and son, he had already moved through the twentieth century's first two decades, supported by the volcanic public erupting about him. Angry at civic ills, compassionate toward human personality, and plagued by an artistic insistence, he thrived on the rumbling expectation the new, demonstrative public served.

Hine came to the "new" New York soon after industrialism came to cities, and like so many other early twentieth-century reformers he wanted to order the chaos that the industrial city was creating. In the last decades of the nineteenth century, industries, population, and labor had grown and shifted. People emerged from diverse backgrounds, from the town, from the fields, even from nineteenth-century life; all streamed into the modern city. Small-town lines conflicted with the new city patterns just as old city patterns clashed with the new. The city became the center of the country's erratic industrial impulses, and the new industrial centers—towns and cities—in turn became wellsprings of hope and cesspools of despair. Growth, conflict, and expectation excited all those who came in contact with them. Reared in the environment of a small town, with little industry and with nature all around, Hine came to the city to seek the new natural goodness rather than stay in the country. He wanted and expected to see a new human magnificence, a transformed humanity rise out of the new industrial seedbed, which attracted all the hopes wooded Nature had traditionally provided.

But even as he hoped he grew angry. As his hopes for the new century grew, so the impact of what he saw and heard affected him more fully. Tenements stank, deaths rose. Diseases increased. Where the threshold of expectation had been a natural woodland for the nineteenth century, the new urban industrial society thrust it forward into the twentieth century—and then choked it. A new chaos came with the new society.

When Hine saw these "un-natural" industrial by-products choking off the "natural," new urban growth, he turned angrily upon the environment surrounding him, traveling twelve thousand miles in the United States alone in 1913. However a person—child or adult—found his relationship to the new industrial world, Hine photographed it. Sweeping. Baking. Waiting. Shipping. Houseworking. Carrying. Arriving. Existing. Hine concentrated on the relationship that bound a person to his society. He caught the harsh reality in scene after scene, face after face, drifting toward children, concerned that they carried "industrial mortgages" on their backs rather than the new urban hope. He moved toward an individual and framed him in his setting. Consistently he found that person's strength. Not romanticized strength. Not dramatic power. Just plain insistent human will—the facet that expected so much from the new age.

In 1905, the same year that Joseph Stella sketched immigrants arriving on Ellis Island, Hine photographed them. In 1907 he photographed slums and Negroes in Washington. In 1908 he started photographing children at play and in the streets. In 1918–19 he explored the effects of war on both people and land in Europe, returning to the United States in 1919. In the twenties he focused primarily on men at their machines. In 1930, as a climax to the decade and unconsciously as an epitome of his own expectations for the urban industrial century, he photographed men as they built the Empire State Building. And in 1933, when we see the photographs he recorded for the Tennessee Valley Authority of Clinch Valley (since inundated by Norris Dam waters), we know that he had found a certain respite back amidst the natural setting from which he came.

He came from Oshkosh, Wisconsin, worked in a furniture factory, fooled around with art forms—mainly wood sculpture—went to Oshkosh Normal, then to the University of Chicago, went on to New York, where he studied further and taught in elementary and high school. He was a local boy in the best sense of the term. He even wrote home to the *Oshkosh Northwestern* in October 1903 of the environment surrounding New York. The Catskills were spectacular: "I spent the night above the clouds and awoke in the morning to an experience new to me. It was a clear, sunny day, with bright, blue sky overhead. Below, shutting off entirely the view of the lower country, was a mass of white cumulus clouds stretching away to the horizon and looking like a great tempestuous sea with white billows dashing high against the coast, which was in reality made up of the peaks of distant mountains." The next year he returned to Oshkosh, married Sara Rich, and carried her back with him to his urban-natural world of expectation.

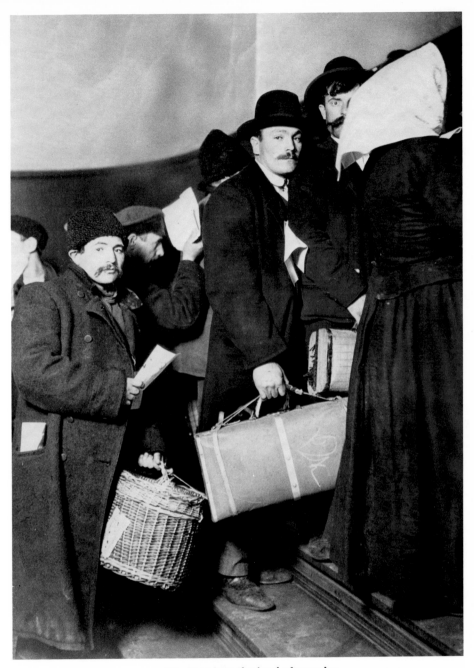

**Climbing into the land of promise,
Ellis Island, 1905**

The captions have been edited from Hine's own words.

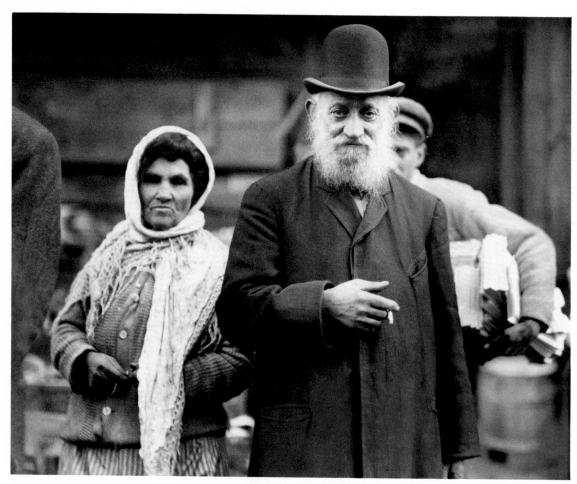

**Man from East Side,
New York City, ca. 1910**

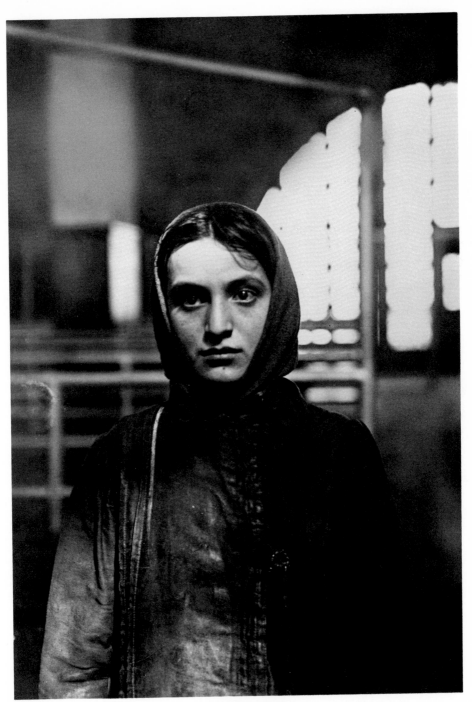

**Young Russian Jew,
Ellis Island, 1905**

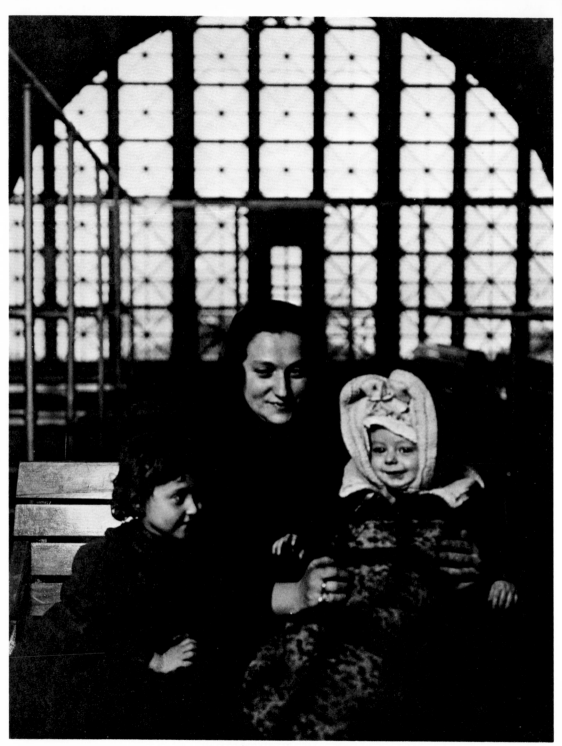

Madonna of Ellis Island, 1905

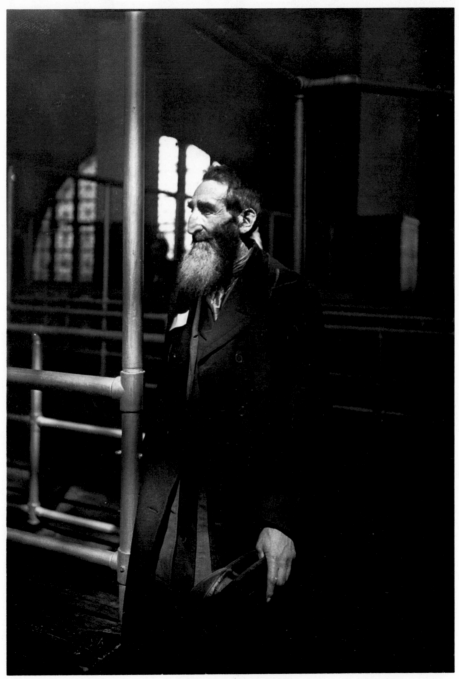

Elderly Jewish immigrant,
Ellis Island, 1905

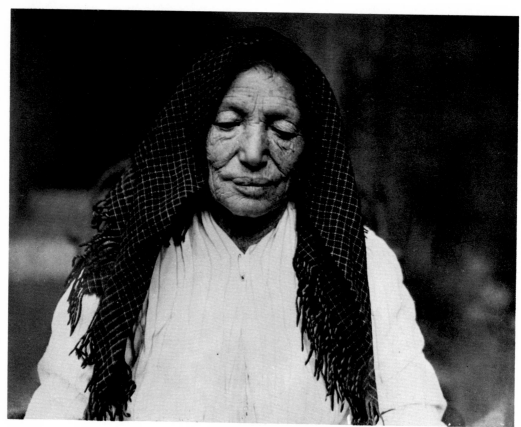

**Forty-year-old woman,
Hull House, Chicago, 1905**

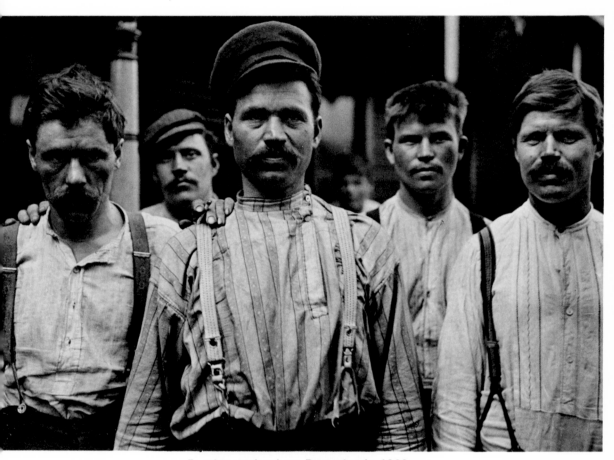

Russian steelworkers, Pennsylvania, 1909

Meanwhile he had been working at the Ethical Culture School in New York City. Frank Manny, who had been head of Oshkosh Normal and first suggested Hine come east with him, was superintendent of the Ethical Culture School and employed Hine to teach botany and nature studies. That was in 1901. In 1903 Manny put a camera in Hine's hand, suggested he use it to teach students—and unknowingly extended Hine's vision.

Later it was clear that Hine always thought of himself as a teacher —teacher of children, teacher of adults, teacher of workers, teacher of corporations. Teacher because he let life filter through him and communicated what he experienced. Although he left classroom teaching in 1908—sliced it completely out of his life—he never cut teaching or interpreting out of his conceptual framework. He felt compelled to arrange his experience for his audience. Hine forever interpreted —nature to children, evils to adults, workers to themselves, the Tennessee Valley to its exploiters. To grasp at some fundamental conflict out of which flowed an abundance of energies and unfold it for others to see, Hine closed in upon a scene. Although the term "interpretive photography" jarred the art photographers, it opened Hine's perspective.

In 1905 Hine received his Pd.M. in sociology from Columbia University in New York City, and met Arthur Kellogg, a Ph.D. student at the School of Social Philosophy. Arthur, Hine recalls, introduced him to social welfare, then to his brother, Paul (later editor of *Survey* magazine); and with Manny on the one hand and the two Kelloggs on the other, Hine entered the new New York City world.

By 1906 the public had already multiplied, and plunging into that "great public," as he, too, called it then, Hine taught and wrote, touching upon social organization, curriculum, light, charity, botany, and how and what children learn. At Ethical Culture Hine had a camera club—and then a camera class. While still teaching, Hine photographed with Charles F. Weller's Washington slum study, went to Ellis Island, wrote about children taking photos on a ferry, photographed for the Charity Organization Society, and also became staff photographer for the *Survey*—then *Charities and Commons* magazine. He created a pattern that bounced with the same intense and often disconnected activity that the new public created.

In 1908 Hine resigned from his teaching post and took on a monthly appointment as an investigator and cameraman for the National Child Labor Committee. By December of 1908, after having exposed glass works in Indiana and West Virginia, night markets in Ohio, cotton mills in North Carolina, Hine's photographs revealed a

reality no one had seen before. Florence Kelly was the first to say so. Introducing Hine's photos to *Charities and Commons* readers, she wrote, "The camera is convincing. Where records fail and parents forswear themselves, the measuring rod and the camera carry conviction."

Although Hine moved through a chaotic tumble of events in the century's first public movements and, like the decade, had wandered aimlessly about, life crystallized for him in front of the camera. Everything he saw, thought, and interpreted funneled through his photographs. "If I could tell the story in words," he reflected in a letter to Paul Kellogg in 1922, "I wouldn't need to lug a camera."

From 1908 on Hine was backed by the rampant and continual rumble of activities. *McClure's* bought. *Everybody's* commissioned work. Charles Edward Russell introduced some of his photographs. He had already photographed some of the *Pittsburgh Survey* volumes; the Russell Sage Foundation asked him to photograph for *West Side Kids.* Later *World's Work* published other photographs. His photo company's catalogue listed over a thousand entries; he made slides for conferences, sold to picture services, and worked throughout the second decade for the National Child Labor Committee. His rumble meshed with the society's.

Whenever and however one looked, that rumble erupted around the child. The factory owner, the educator, the prohibitionist, the reformer—all focused on the child. Educators revolutionized the curriculum children were to experience in school. Prohibitionists abhorred children learning sin from the streets. If anything seemed to draw groups together, if anything seemed to present a beacon for the separate movements, it was the sheer existence of and hope for children. As recipients, doers, beholders, as pre-existential beings, children became the focus of life.

Hine joined with the child labor reformers and even helped explain some of their aims. But he always spoke from behind his camera with a power he particularly created. Look at his photographs. Each child is named, placed, and aged. Olga cried as she sat on her house steps. Rose asked Hine to "photograph her dolly too," and Mary "tends the baby when not shucking." Each cotton mill in New Hampshire or North Carolina becomes distinct, each child and his work defined. The individuality with which he saw people, factories, hillsides, machinery, gates, tenements, remains in the photographs.

Some of Hine's most eloquent photographs are of children, individual children classically posed in a world bubbling with change

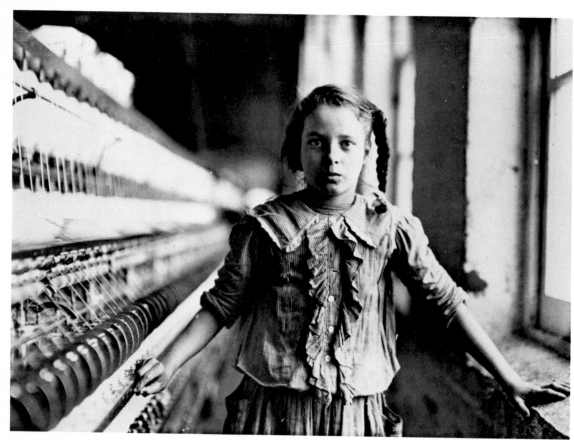

Doffer girl in New England mill, 1909

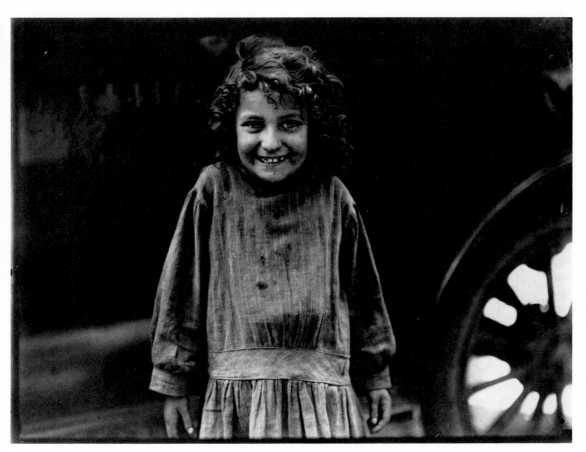

Paris, 1918–1919

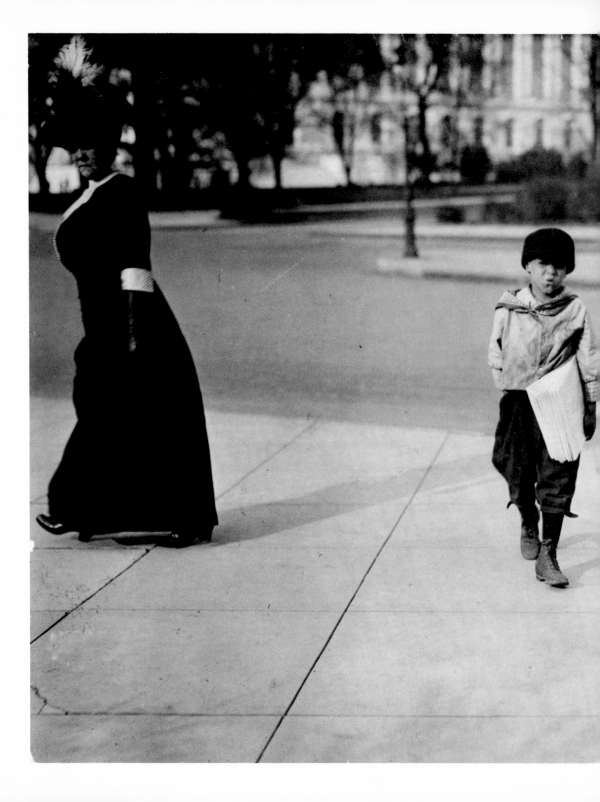

Danny Mercurio,
150 Scholtes Alley, Washington, D.C., 1912

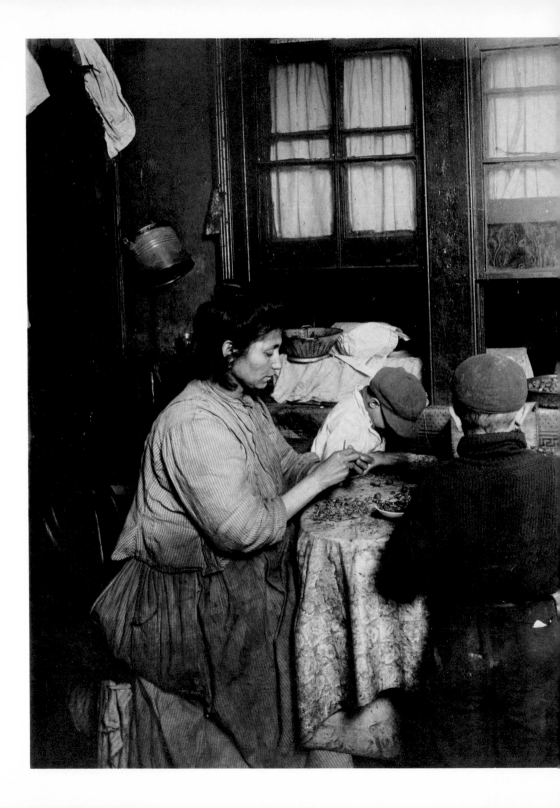

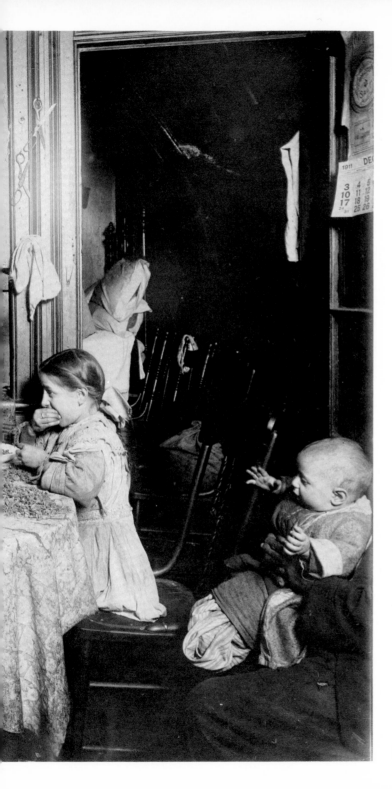

**Mrs. Raphael Marengin,
New York City, 1911**

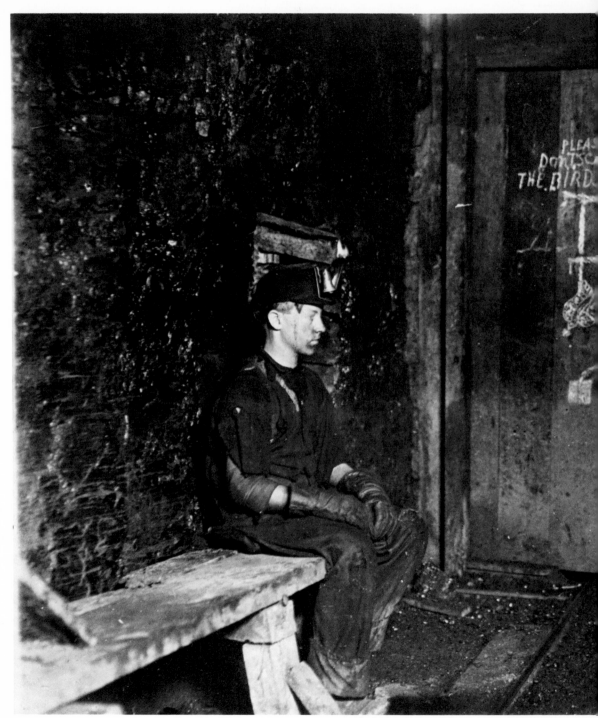

Vance, a trapper boy,
Coal mine, 1911

—a boy leaning on a machine, another boy standing, a young Jewish immigrant. Hine saw the child become the resolution of aesthetic and historic conflict. As if they were the purest flowers transplanted Nature could cause to grow, Hine's children become classic statements. They fuse rational and moral conviction, especially his conviction that in the new age one should be able to find laboring contentment in the city, that new growth was natural, that it needed only to flower under its own power. Child labor was an evil. Cut down the evils and let the children grow.

To locate the evils and find the hidden purity, Hine traveled from north to south and east to west, mainly between 1909 and 1916. New England cotton mills. New York City tenement-home workers. Baltimore canneries. Biloxi fishing boats. St. Louis streets. Colorado beet fields. California canneries. Wisconsin cranberry bogs. He visited families at home, read Bibles for birth dates, measured heights of children against his suit-coat buttons, and when he was not allowed into factories, waited outside to photograph the leave-taking or the 5:00 a.m. dimness that started children on their day.

"Should" was a part of Hine. Morality counted. An age-old Protestant concern infused his now urban expectation. In addition to a rational and naturalist-scientific expectation that arose out of the transformation of a woodland threshold into a machine-dominated society, a now-secularized, formerly religious but still rigorous morality dictated to Hine. It was wrong and sinful for children to be shooting craps out in the street at 1:00 a.m. That their work was inefficient, that they did not learn—these were parts of an unmanageable, even inflammatory argument. But underneath that indignation, he considered children's working as sinful. "The messenger boy carries notes between a prostitute in jail and a man in the red light district," he noted in a report to the National Child Labor Committee. Child labor needed abolition because it was inefficient and irrational. Also because it was wrong.

But in 1914, after seven years of investigating and photographing children at work, despair seems to have seeped insidiously into Hine. Children still picked nut meats and stitched dolls' dresses in the home. In North Carolina the minimum working age went up one year for girls—to fifteen—while a prominent manufacturer wanted to install knitting machines in the homes of the workers. To annex the homes! Education had made no apparent dent. To whom had he been interpreting? How far away Hine's hopes for self-expressive fruition must have seemed; how foreign his hopes for the child of the century

must have become. Reform may have gone as far as it could. World War I broke out in Europe while Hine was still concerned over this country. But increased war talk shaped some of his energies. He photographed army camp training for *Everybody's.* He hoped the Red Cross would use him, matter-of-factly accepted its improbability in 1917, and then was delighted to leave for France in May of 1918, a captain in the American Red Cross.

After six months in France Hine was attached to the Special Survey Mission that Homer Folks, Charity Commissioner of New York, headed to investigate the war damage on people and land in southeastern Europe and northern France and Belgium. Leaving Paris on November 11 as the Armistice festivities broke out all over the city, they arrived in southeastern Europe in November. Folks wrote to his wife in Paris on December 13, 1918, "I don't think Hine was ever so happy in his life as here. Something new every minute that he wants to snap. He is out all day picking up interesting things on every hand." Hine was happiest when he was creating. These photographs climactically express the individuality he found in the continually multiplying world.

By June of 1919 he returned to New York, checked in with the Red Cross people, and then looked about. Energized by the humanist resolution of the war and his own perceptions, he was eager to start business again. Doubleday prepared a four-page spread of his European photos for *World's Work,* Homer Folks used them in his *Harper's* article and in his book, *Human Costs of the War,* Paul Kellogg used them in *Survey,* and in 1920 Hine did a fairly spectacular issue on Pittsburgh and steel in *Survey.* When both the National Arts Club and the Civic Club presented a one-man show of his work in 1920 and 1921, it looked as if he had found a direction for the exaltation that he had slid into, the uphill swing the country experienced from out of 1919's floundering.

Reviews were spectacular, even of the conception and place of the show and the building. Hine was the first photographer to have been exhibited by the artists, and his Civic Club show drew praise from *Literary Digest* and the *New York Evening Post.* His base of appreciation was the widest it had ever been. Commitment and artistry, critics said, joined in Hine's work. The *Literary Digest* wrote, "In his pursuits as a sociological investigator and recorder, Mr. Hine had, whether consciously or not, employed his instincts as an artist." He was at a pinnacle.

Yet right after the show he wrote off to Frank Manny questioning, wondering—no, angered by the absence of an old world. Though

maintained by a photography and art world of critics, supported by a changed group of institutionalized social welfare critics, and elevated by the widest base he had ever had, Hine was bitter. Where was the old "fun" he wanted to know, the "fun" that came out of "fundamental"? The fact that support for his show was wider than it had ever been was essentially insignificant. The base that had supported him as a person, that had received and woven and then elevated his private world of expression was now faltering.

A new national blanket covered the old particularist expectations. Where "civic" and "public" had maintained the separateness of the country's years before the war, now "democracy" and "national" swept it all into a new, power-ridden drive. The potential for power gave way to power itself as multiplicity at the bottom gave way to cohesion at the top. A public became a nation.

And where Hine was educating the "public"—the myriads of people who were creating the great new society in 1912, in 1921 he was educating a more defined column of people: workers and industrial managers. He expected the photographs he took of men in industry—"work portraits" he called them—to document how the worker personally took up the challenge of industrialization. He expected that they would help a worker see the beauty and greatness of his work. Hine photographed "Men at Work" throughout the decade. He photographed men on rigs, men turning bolts, even an industrial camp where children were being taught to run the new age's machinery. Some of his work was even pirated—a sure sign of success. The Art Directors' Guild awarded him *the* prize for photography in 1924. But he could not find a public.

The photographs for the most part are stilted, formalized, and lacking in feeling. Abstractions of reality, they rarely catch reality. An intellectual conflict hangs heavily within each, but real conflict is missing. Hine tried hard to identify with the new society. But the communication he had had with the old public he no longer had with this new institutionally directed life. His vision no longer matched its vision.

By 1930 Hine felt disjointed. He wrote to Paul Kellogg that he was thinking of selling his house and moving to a rural upstate community "where there is more underfoot than 'overhead.' " Perhaps pure Nature was the only source of life for Hine after all. If the counterpointed rhythms of life and labor in the industrial scene could not cradle him in contentment, then perhaps the timeless, soothing satisfactions of Nature could.

Child jumping up and down in an effort to weigh himself, New York City, 1911

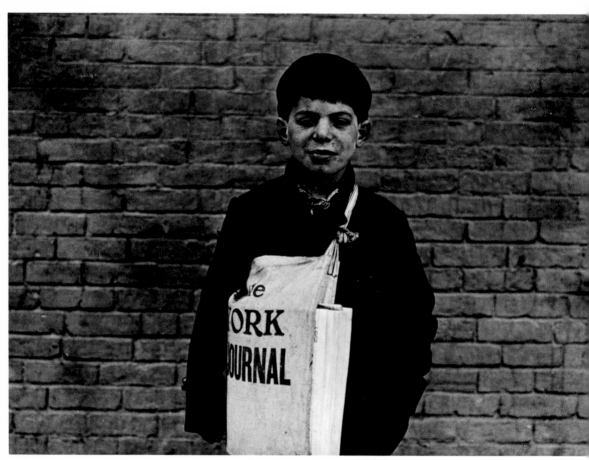

Tony Casale, newsboy, ca. 1910

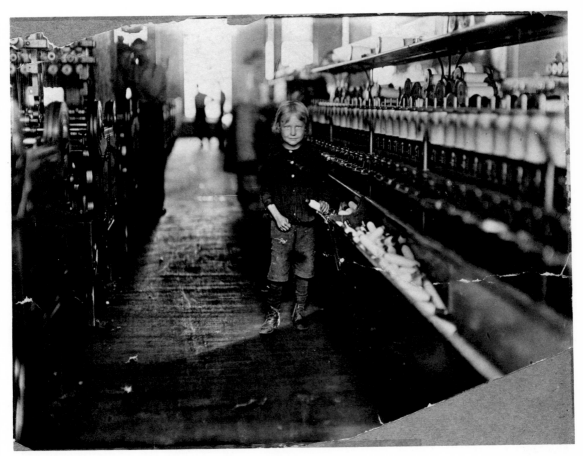

Child doffer,
textile mill, ca. 1910

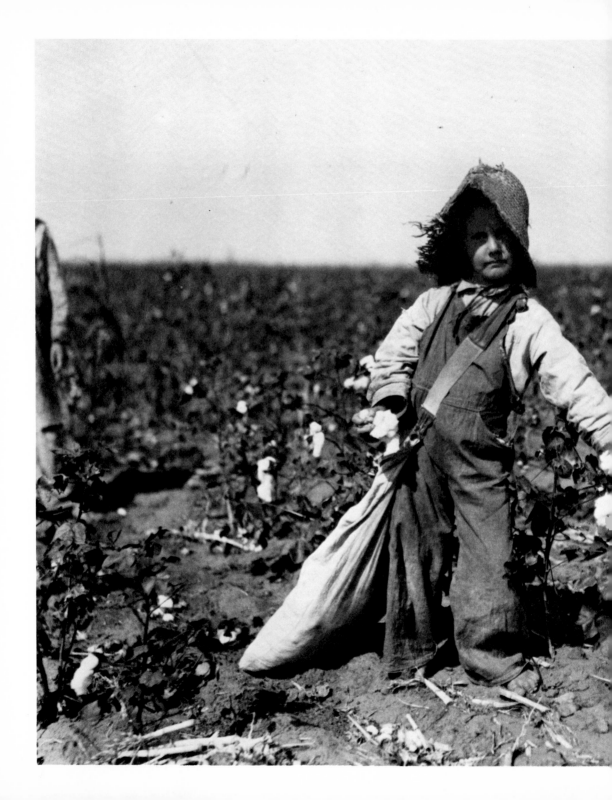

Child picking cotton, 1929

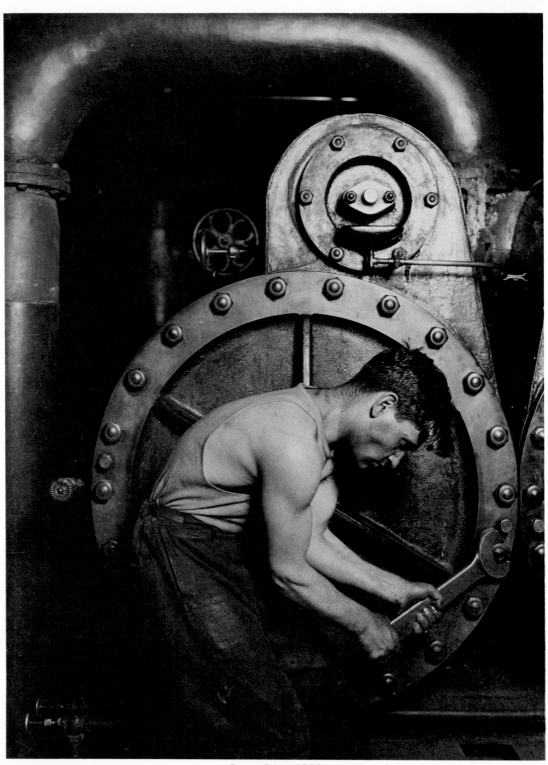

Steamfitter, 1921

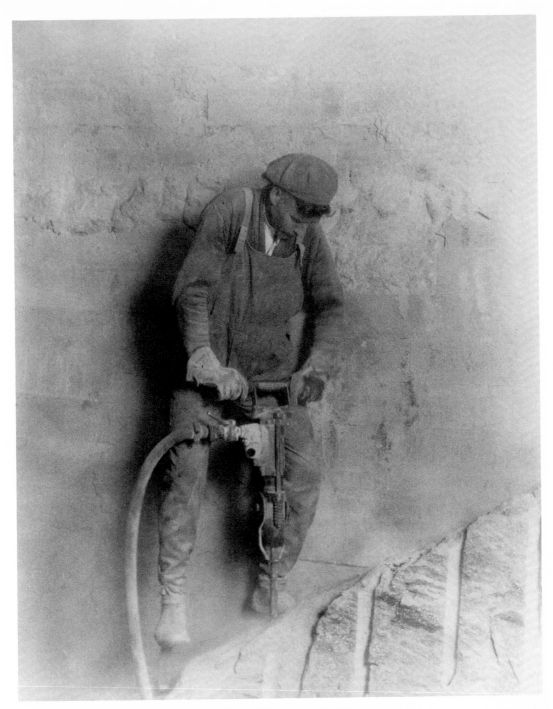

**Man with pneumatic drill,
Empire State Building, New York City, 1931**

He never moved. Instead, in 1930, he recorded the building of the Empire State Building. In close to a thousand exposures he photographed the men who built it and the structure they created. He caught the towering sensation of mastering both Man and Nature: Man because this building topped all that men had formerly built, Nature because *it* still underlay all. The building symbolized a potential for greatness; it harnessed "productive" energies—a word Hine loved and repeatedly used. And as the building climaxed one expression at least of the new century's power, it also matched that power with the power a worker gave to the structure—and the age. "I have always avoided daredevil exploits," Hine wrote after completing his Empire State work, "and do not consider these experiences as going quite that far—but they have given a new zest . . . and perhaps a different note in my interpretation of Industry."

Though some of the photographs catch the counterpointed rhythms of human and machine-driven life and masterfully exploit the suspension between the two, he could not stay out on the plane of power it suggested. He never moved back to a rural setting, but his best photographs in the thirties after the Empire State scenes are of rural people—portraits of older people usually, one or two of children—and settings. His conscious self stayed in the city. Personally and artistically he wandered back to the country.

In 1932 when Hine published his book, *Men at Work,* presenting his industrial photographs of the twenties, he prefaced it with a section from William James' "The Moral Equivalent of War." For Hine the human condition would have its most flowering embellishments when the infuriating fervor that men could marshal could reshape societies. Though Hine had climbed to the topmost tower of man's mastery over Nature and then ambled with men's potential in Nature's garden, though he had memorialized human strength and beauty, though he himself spoke in his TVA proposal of "constructive conquests of peacetime, rather than destructive, aggressive acts of warfare," he still searched for the most perfect expression of man's strength.

Machinist, 1921

In 1939 the Carnegie Corporation denied him a grant to prepare a permanent folio of his photographs, and though terribly wounded, he wrote to Paul Kellogg that there was "still plenty of fight left in this old hulk." In that same year Beaumont Newhall, then a young art critic, visited Hine after reading of him in an article by Elizabeth McCausland, and then wrote of his work to a new and younger art photography world. It looked as if he might experience some new wave of respect. CBS asked him to prepare a series of broadcasts on the

Cowboy of the yards, 1921

working man—on his idea of life and labor. Soon after, the BBC in London asked him to prepare a similar sort of single broadcast. He was pleased that "a couple government guys [think] my documentary photography [is] the only work of that kind between Civil War Brady and the present." *Life* bought up some of his "old treasures." Ramona Javitz at the New York Public Library assembled a group of his works for a permanent collection. Charles Adams in Albany (Hine's old economics teacher at the University of Chicago) set up a permanent exhibition at the New York State Museum. And in 1939 the Russell Sage people commissioned him to prepare two folios of his life's work, one on child labor, another on immigrants. This was the same organization that had printed many of Hine's photos in the first and second decades. And a third and fourth folio were being negotiated.

But when he died suddenly a year later there had not been enough to build a base. The Museum of Modern Art in New York City refused his collection. *Who's Who* had already dropped him. A *Dictionary of American Biography* article could find only limited place for him, and Ewing Galloway, a picture service agency, echoed that sentiment, putting his negatives on the inactive shelf.

Yet his work never vanished. In recent years more and more Hine photographs have appeared and reappeared—as if surfacing from some insistent underground current. Hine photographs illustrate TV specials; labor union advertisements use them—to sentimentalize the past and usually with no credit to Hine—but use them. So, too, with book illustrations and magazine articles. Up to now his images have been too far removed from the present, even too far removed from the imminent sense of revelation one needs to be gripped by a work of art. They've been in the background—just like "old favorites," as he called them—and one has stumbled on them. Now our years are catching up with his vision. While his images slid onto a sort of national subliminal shelf and became a part of our national conscience, the eyes of his subjects continued to haunt us—almost insidiously. That his own "restless human soul" outgrew its origins, that it burst all the conventional bounds of photographic inspiration and practice, even that it soared into genius, Hine wished for but probably never fully understood had happened. We are just beginning to realize its relevance and see what it saw.

Hine could not live in the world of photography. The Photo-Secession group experimented and incited, but within defined limits. It attracted those interested in furthering photography as an art form. It did more than any other group or movement to implant photography

The Bowery, New York City, 1910

as an art form in the public eye. But it did not provide the haphazard, exciting raw edge—unfinished but compelling—that an individual like Hine needed. Protected by his camera, utterly committed, Hine looked for blatant life. He searched where he was not wanted, photographed where the owner objected, and found the word "detective" described the work that pushed him into continually new conflicts.

How much did Hine "see"? How much "luck" entered the scene? Any good photographer constantly talks of "luck," for the field of vision, especially in a view camera, does not duplicate the filmed image. What turns up on the film could just as easily not turn up—as far as precise judgments are concerned. But Hine so consistently framed a scene in the same way that the pattern of "luck" frames our view of his work. He organized people rather "simply" in front of the camera. A whole group lined up outside the factory gate and Hine presumably came along and simply caught them as they were. But once our eye starts into the photo, it continues, weaving across the heads grouped in the lower right, stopping off-center at the factory gate entrance, and then running out at the top left. In fact a high degree of order rests between these groupings, enough to propel the viewer's eye more swiftly and evenly than he is aware of. It's more than luck, at least a pattern. Of course to Hine the significant fact about each photograph was the statement he made. Anything more than that statement probably remained irrelevant. He trained his eye to make that statement more perfectly.

Each particular conflict Hine abstracted probably represented a timeless human conflict more than he ever suspected; and as we see these same photographs today, the movement that was locked within the historic reality seems to be spilling out. Today's experiences add to the figures in the photographs, and artistic movement that ran rather "simply" between planes in 1910 now runs in excited patterns. The "simple" or "primitive" organization of people in front of the camera that ordered a past chaos held explosive feelings intact. Today's human wants—not tangible wants—pry open those explosive feelings and spread them all over the photograph. Within that "random" order Hine abstracted a meticulous expression of continuing human conflict; triggered by the years of new life, that expression flows from group to group. The people seem more real, more pervasive even after the passage of years. The settings pungently balance and unbalance, revealing the figures more fully. Finally both the soul and the face of the photograph become real.

The truthfulness of any art, the degree of honesty it can communicate, becomes its agelessness. The most perfect abstractions

 KALAMAZOO VALLEY COMMUNITY COLLEGE LIBRARY

that can creep into a representational form are what flow out of that art form in later epochs. The gap between what was explicitly stated' in one age and what a later age takes out becomes narrower. Only the best art can order the chaotic tumble of events. Only the best can realign chaos to suggest both the chaos and the order it will become.

Out of commitment Hine did this. Not a commitment to art—but a commitment to expose the horrors so that the most perfect living order could take shape. Disregarding fashion, Hine broke into the new reality. And just as Picasso used a profile to cut into a whole man, Hine cut off a man and broke into a whole reality. Like Modigliani's technique of cutting off legs to bring the nude right up and at the viewer, Hine's cut-off reality foreshortened perspective and brought the viewer upon the new, whole scene.

Design always challenges formlessness, whether it is human design challenging human formlessness or pictorial design challenging pictorial formlessness. Lumpen formlessness will not stay that way. The desire for order prods it. Force the rampant run of movement. Tighten it with design. Thrust light at an unexpected subject, recast planes, counterbalance lines against people—and the counterpointed rhythms can only explode. Conflict within art increases the communication.

Out of the unquenchable desire to find the most perfect living order Hine ended up creating a new artistic order and shaping a new art form. Not photography. Steiglitz and the Photo-Secessionists did that in this country. It was a kind of photography he called "interpretive," and later schools called documentary, a base from which the F64 people in San Francisco and the Bauhaus group in Germany saw in the twenties, a flat fiery arrangement of people, light, and form that became a timeless humanist art.

The particular situations Hine saw are gone. The splintery wood posts and picket fences and pinpointed array of pebbles are all gone. Even the overt horror he wanted to communicate is gone. But overtly furious with the evils of modern life, he roamed around behind them and saw only the particular people and how they felt about their situation. He shaped people as they saw their experiences, as if they had most perfectly abstracted crucial conflicts from their lives. In a way Hine did not interpret at all. He just came closer and closer to that humanist essence that binds truth and beauty together.

Copyright © by Judith Mara Gutman. Abridged and revised by Judith Mara Gutman, 1974, from "Lewis W. Hine and the American Social Conscience," published by Walker and Company, New York, 1967.

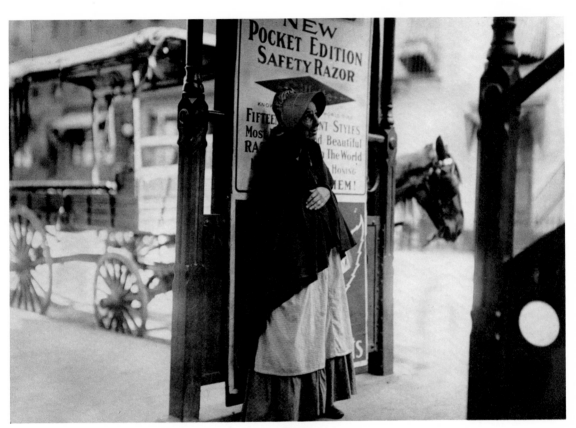

**Beggar,
New York City, 1910**

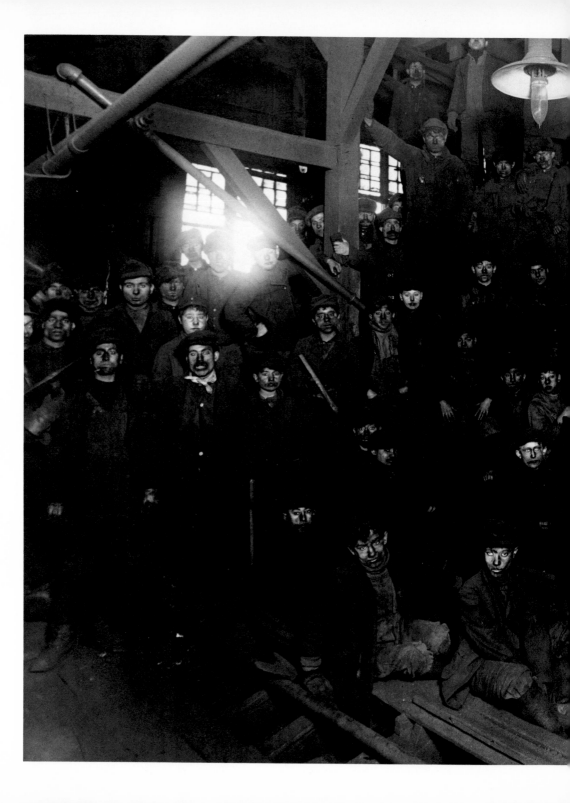

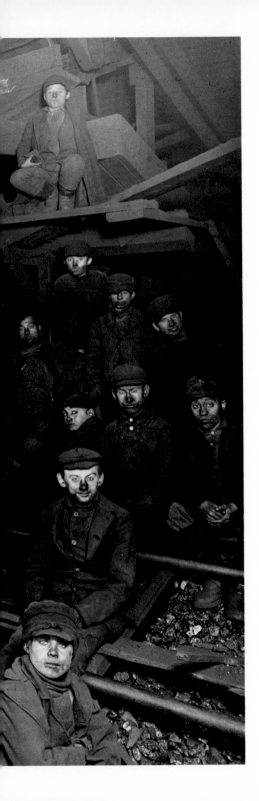

Breaker boys, coal mine, 1911

The eyes
of
Lewis W. Hine

Seven years ago when I wrote the preceding comments on Lewis W. Hine, they were considered a little offbeat, a bit out of the normal range and ken of the way one should speak about Hine. It was unusual to give credence to him as an artist —after all, he rarely cropped a photograph, we know he was short on technique, and he never tried to become part of the circle of artists who thrived off one another in the early twentieth century when artists, reformers, and businessmen each produced a billowing image of the life they expected would only become larger, shaping a newer and better world. It was also unusual to think of Hine exploring the human condition, to think of him dipping below the surface of reform to reveal the texture of life a person lived as he went about his normal affairs. It was much more usual to talk of him as a reformer with a camera, a man who showed us the evils of child labor and what children looked like in mills and factories.

I struck out in that vein because of his photographs. The first group I saw showed me the nature and character of his concern. As I uncovered more, they only widened and deepened the ways in which he probed the society around him.

In the ensuing years the wheels I had set in motion continued. People continued to send me photographs. Visitors and letters continued to arrive. And once I spread all of this new information out and let it tell me what it was about—once I watched the design it created—I saw that the earlier statement I made about Hine is true but insufficient. It's accurate as far as it goes, but it fails to show us how Hine was infected with the great and glorious new life that he, too, expected the U.S. would create. It also fails to show us how Hine was taken with the romance that Americans developed as they brought telephones into their living rooms, drove over sunken, muddy roads, and dreamed of slick, ponderous Packards. It doesn't tell us how he was affected by the very conditions as they improved and how he was affected by the new technological society that was growing independent of his dreams and wishes for improvement. It doesn't show us how he was

tied to the real and illusory new human configurations that American technological society imposed on an older industrial order.

For if Hine put us in touch with the minuscule strands a person felt as he worked in a factory and the magnificent outward pulls an immigrant felt as he entered a new country, he continued to show us how a world built itself within a person at the same time a person went about his daily business and built that outside world. Right up to the day he died.

All of this became clear when I looked at the "new" photographs that came my way. Mainly of machines, they looked much like any photographs of machines that any photographer ever took in the 1920s and 1930s. Only at first. After some months went by it became clear that Hine's and not the others' stayed in my mind, that Hine's photographs were rolling around on those subconscious levels that infect the thinking processes and finally make them erupt. I realized that his were different; they told us something about American life that the others didn't.

His photographs showed us that the whole center of industrial life in America had shifted. Nothing less. Where we had always been able to pinpoint the center of industrial life and see that a person occupied that same spot, we could no longer do that. Whether a person was trying to free himself or accept his burden didn't matter; structurally the person and the industrial center meshed with each other. But in looking at Hine's machine photographs we see that was no longer so. The two centers no longer occupied the same spot. We could no longer understand the tick of industrial and technological life by locating a person. A person wasn't there. A machine was. The machine had come to occupy the central focus of American life. But more, Americans had turned the machine into a person who looked out at the whole world in the same way that a boy or girl had.

And the people? Where did they go? In 1937, just three years before he died, when Hine photographed for the National Research Project of the WPA, he showed Americans how they were stepping behind the machines they had formerly run, how they were backing up the machine they had formerly employed while they stayed in the background, in shadow and half hidden. After all, what kept spilling out from my subconscious were the shadowy half-images of women behind spools, the faded, dim faces, the half-expressed smiles, the thumb sticking out of Mr. Frank's pocket becoming more important than the rest of him. I saw parts of human expression becoming part of the movement of the spools and the continuation of the assembly line. I saw people whose place, role, and importance lent themselves and their characteristics to the pattern of the machine and

the movement of the parts that fed it its life. And then those new glaring eyes. I saw the machine rise out of these photographs as a great and glorious new human being.

What makes Hine's machine photographs so upsetting for us today is that they show us how the machine, and not the person, saw life, how the machine had become the person with vision looking out over the whole panoply of life and concern in the United States. What makes some of us want to throw these photographs aside— just cast them off and make believe they don't exist—is that they show us how a person became an arm of the machine, how the machine was the vital living element in the photograph and the arm or face just an extension of its life. What appalls and infuriates some of us still further is that the segment of the person we see is usually

quite content and pleased. Often full-bellied and round. We don't like what this tells us about ourselves.

By 1930 Hine had developed a surrealist vision in order to show us what was happening to life in America. Where earlier he had seen people dream, and think, and try to build a better life, now he saw machines trying to do just that. And where earlier he had seen the way a person used a machine, now he saw the way a machine used a person. The spool and the assembly line, which formerly took their places in the pattern a person controlled, now controlled the person, who took his place in the pattern the spools and assembly lines created. The person became the offshoot of the spool. It wasn't that Hine was askew, rather he was watching new dreams surface. In the 1920s and 1930s Hine let his vision follow the dreams that were circling up through the movement that Americans saw rise into a great new technological organization of standards and taste through all of American life. Rather than asking us to look into the eyes of those people he had photographed in 1910, he was now asking us to look inside a new human being. He was asking us to look into new sets of piercing eyes.

It's not that he loved or hated it, or even that he felt the machine's eyes did indeed look out over the world. I tend to think, in fact, that he still hoped for some great joining of man-made and industrial life into a new humanist core. It's rather that he saw it happening. He saw the way Americans looked to their machines, and he developed a surrealist vision to allow those dreams to live.

Once we stay with his vision and look at the world the way he saw it unfold, we become aware of the fact that he was always showing us what Americans wanted, hoped, and feared. We also become aware of the fact that he always saw the life he was photographing through the eyes of the persons he was seeing, that he let a person's eyes organize the whole photograph. It becomes clear that he saw different kinds of eyes in different moods, and that the way he organized his photographs depended on the dreams he was photographing. To understand what he saw and to show

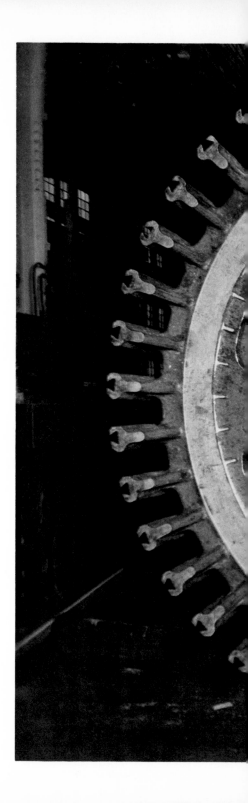

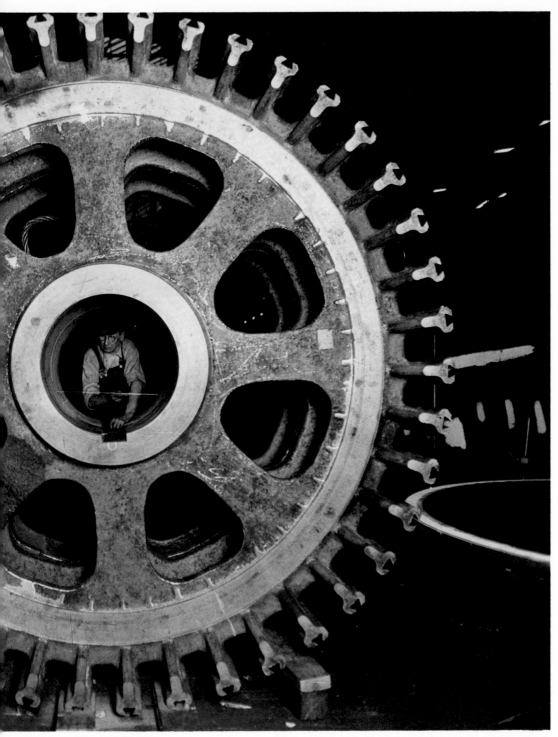

Man at dynamo, 1921

the way his mind and eye reached into the interior of American life, the rest of this book takes its shape from the eyes he photographed and the dreams and wishes he saw Americans expressing. If there's ever an eye we identify as his, it's this Direct Eye. This was Hine's most social eye. It was the eye that informed a population about conditions in mills, about children who worked in canneries, and about people who walked to work at six in the evening when all families were supposed to be sitting down to dinner. It was the eye that told people what went on inside areas of life they never experienced. But never softly. Never meekly. Meeting people head on, it confronted them and swept them over to the other side of the fence with one clear, direct stroke. It was an eye that communicated from one world to another, an eye that reached through space. In the years since, its power has increased. In addition to lifting us over to the other side of the fence, it also carries us back in time. We see the details of another way and an earlier period. It breaks through the clutter of both time and space.

The Direct Eye also opens us to flavors and nuances of that other world. We realize that we are watching the swing of a dress or the stride in a walk. We find ourselves thinking and watching what we would call irrelevant parts of another way of life, even ducking back under the eaves of a house or meandering inside some shadows. We find ourselves living inside the subject's world rather than just looking in at his time and place. We find ourselves thinking and feeling with flavors that the subject himself used.

We also learn about a person specifically. We learn where she or he lived; how many sisters and brothers he or she had; if there was a father, what he worked at and often what he had to say about the job he did. The captions that Hine provided for these Direct Eye photographs are usually filled with specific information that makes a person stand out and become the particular person he was.

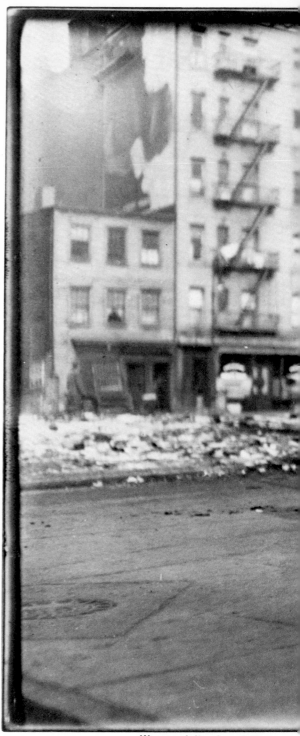

Woman delivering clothes,
New York City, 1910

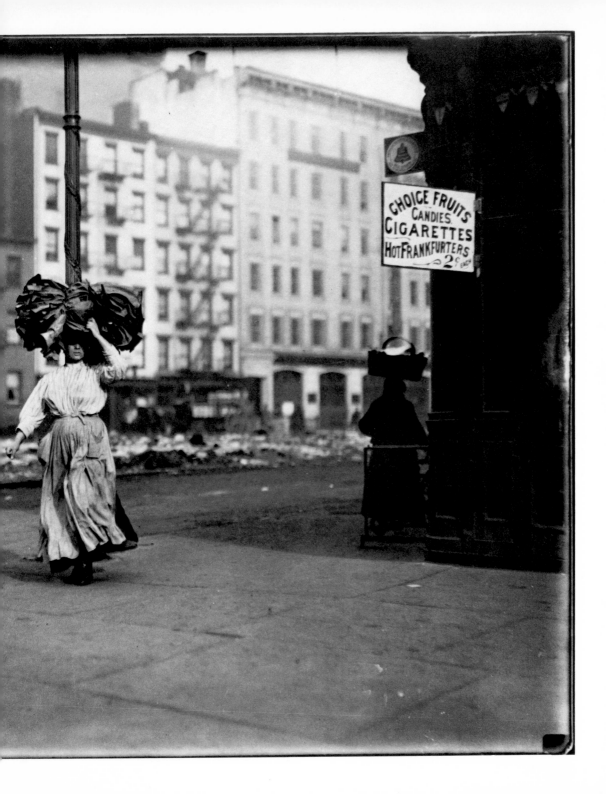

Look at Mammy Young in Tifton, Georgia. Moving back into the recessed plane of her mood, manner, and style, we then come up front with her direct command. We learn that she is the next oldest girl in the family, that she runs two "sides" in the mill, that she and all of her sisters and brothers earn $4.50 a week, and that it was January 22, 1909, when her picture was taken. We live with tangible and intangible parts of her life, with feelings and moods that are both evident and unclear. We live with the pulls and stresses that she feels as well as the clearly evident details we can see.

Hine used this eye to show the contradictions a person felt—how a strong person was also vulnerable, a young person looked old, and a triumphant person might never triumph. Hine used this eye as a way of exploring the range of feelings a person experienced and the contrary pulls he felt as he performed what seemed like clear overt acts—feelings that were sometimes nagging and sometimes satisfying. Drawing viewers into another life, he tied a viewer to the range of fragments a person experienced. When Hine used this eye, he so extended a person's thoughts and feelings that he combined an existential run-off of life with a flat, fiery passion that had a pace and design in itself. Hine brought us into another world with this eye. But we often feel strange; we want to find out so much more.

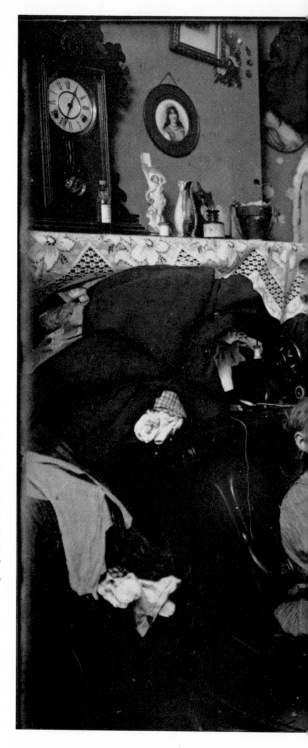

Family in tenement, 1910

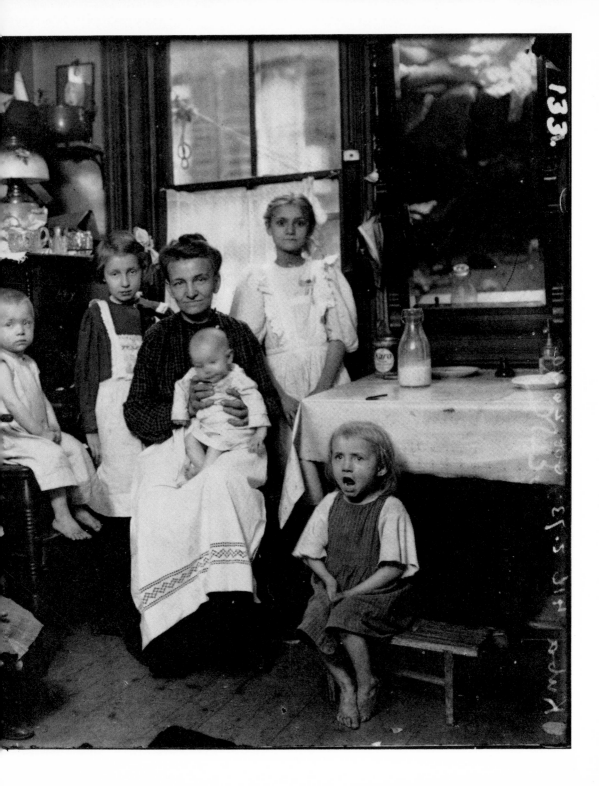

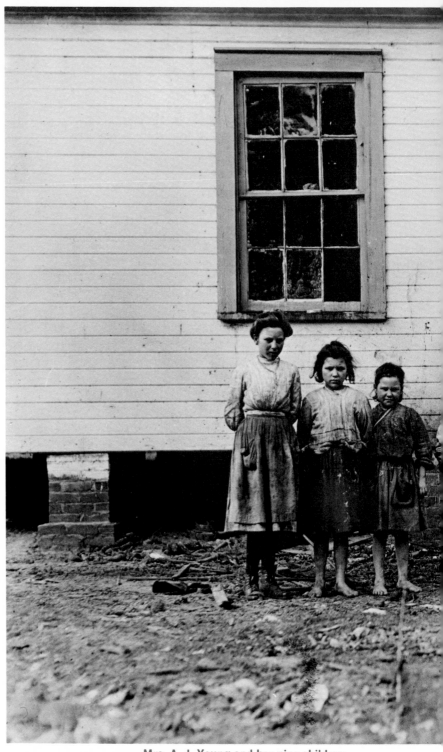

Mrs. A. J. Young and her nine children,
five of whom work with her in Tifton, Georgia, cotton mill, 1909

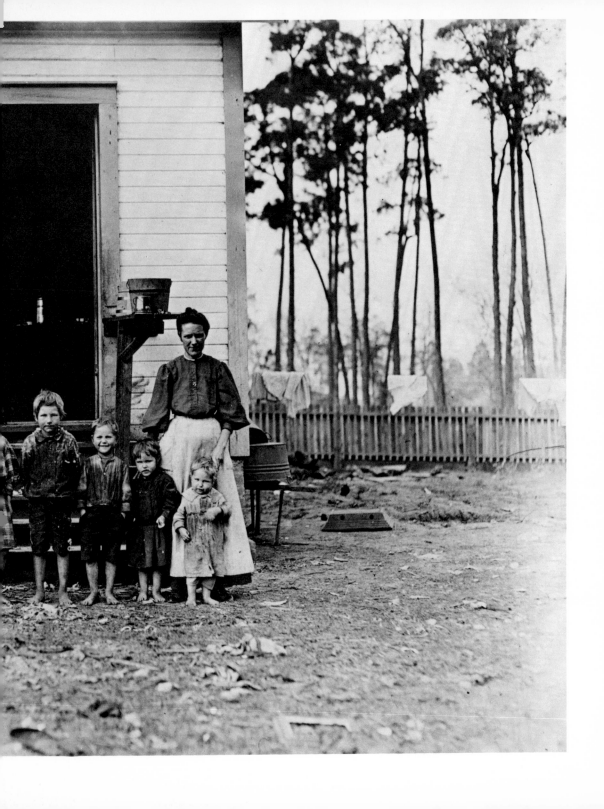

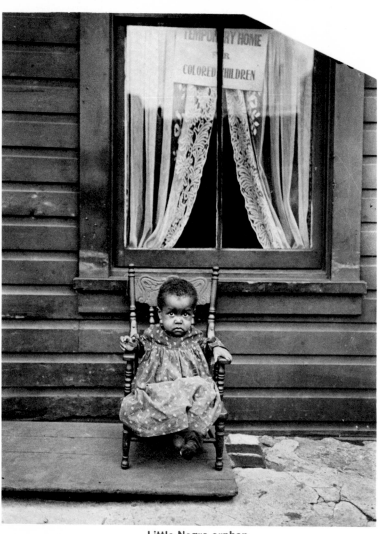

Little Negro orphan,
Washington, D.C., 1906

Paris gamin, 1918–1919

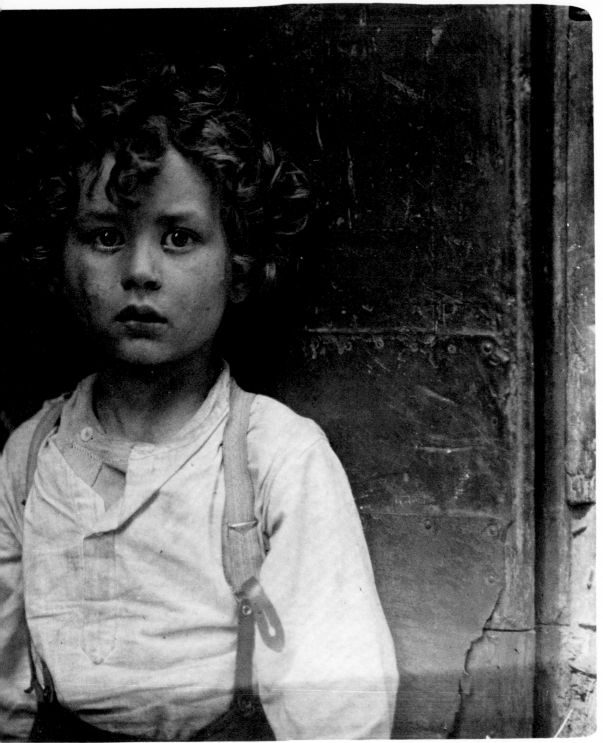

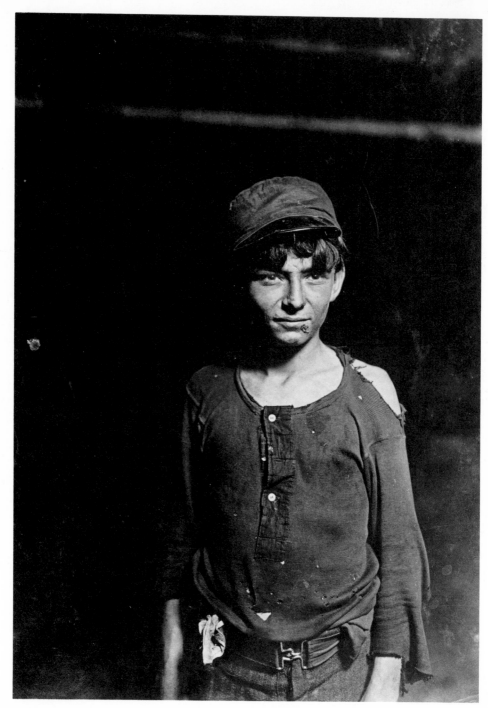

Glass works boy, night shift, Indiana, 1908

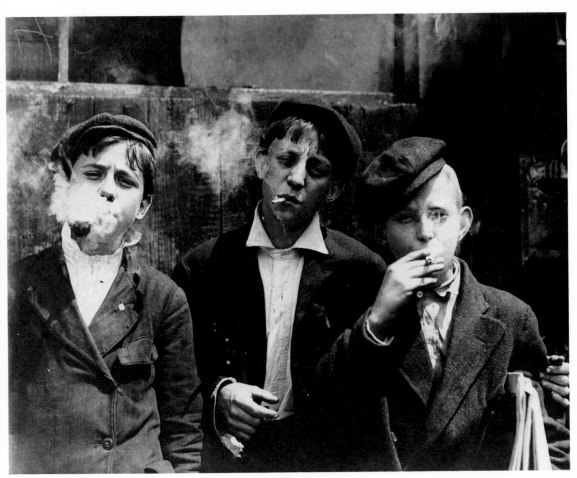

Newsies at Skeeter Branch,
St. Louis, 1910

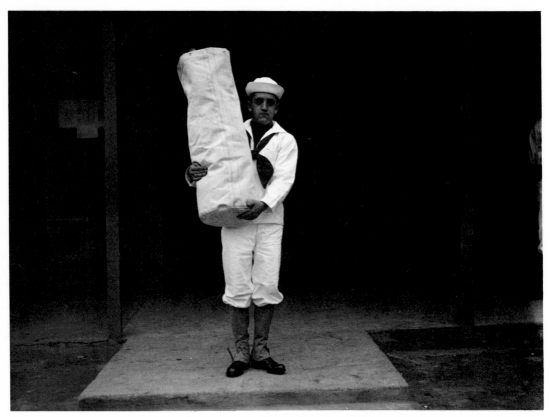

Army camp: sailor with seabag, 1917

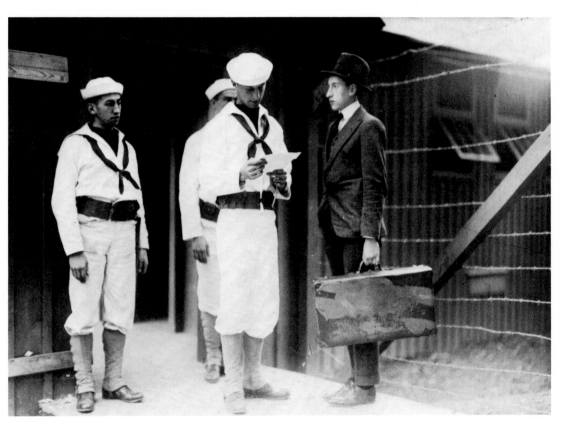

Training camp, 1917

The averted eye was different. It probed, opened segments, and poked into a situation. But only did that. Nothing more. It never threw life open. It didn't reveal or spill out an internal life. It only allowed others to peer into a life, to get an inkling. This was the eye that cut through a photograph at a forty-five-degree angle. This was the eye that side-stepped issues, that allowed Americans to see how they were avoiding life even as they said they were confronting it.

Didn't Americans tell themselves they were actually building that great and glorious new life they were sure would become the heartland of all America? Didn't Americans tell themselves they were actually shaping the giant new civilization that technological America was supposed to be? Didn't Americans gloss over the wrinkles that crept into their view, all the while accepting the glitter and romance of the new technological society? Didn't Americans tell themselves they were exploring even though they were standing pat, that they were searching beyond while they were in fact staying put? Didn't Americans use a vision that never allowed them to run up against the rest of the world?

Hine also consistently saw Negroes using this vision to separate themselves from the outside world, which they thought they were penetrating, while in fact that vision kept the outside world from ever entering their thoughts, thrusts, and demands. Hine saw Negroes using a vision that cried out with an anger and desire at the same time that it quieted itself down within a curtain of silence. Look at the Negro girl with the white doll. It was the eye that curtained life off, that held itself intact. This eye separated one world from another. It maintained each.

What makes this eye so far-reaching in its containment, so loud even in its quiet, is the way it tells us about life in the whole United States in the 1920s. It tells us how Americans were turning inward while wanting something more, how Americans were closing themselves off in the process of saying they were changing. Following this eye through a photograph we never come upon a situation head-on, but rather feel ourselves sliding into a situation, slipping into a world where we can't yell or shout but want to come to terms with the vibrant new parts that shake it up. There's a quiet fury in these photographs. Hine saw Negroes using this eye in the 1920s. But he also saw whites and, in fact, the whole American society using this vision to avoid a direct confrontation with the new technological order that was supposed to blossom into a magnificent new center of creativity.

When we follow this eye through a photograph we suddenly realize that we rely on all the peripheral areas to tell us about the persons in it. We use the shape of a body, the drape of shoulders, the stoop in a person's posture. The eyes don't tell us what's going on; they just slip us into the scene. Once inside, we use all the other details we come upon to bring the scene to life.

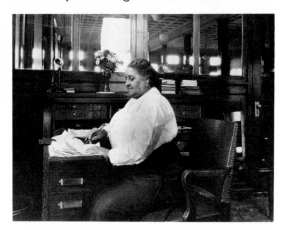

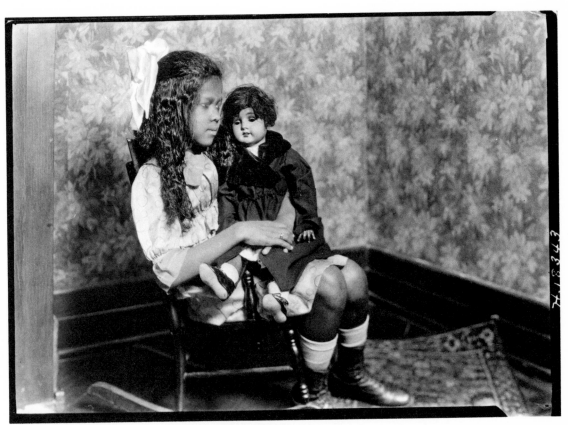

Girl with doll, ca. 1910

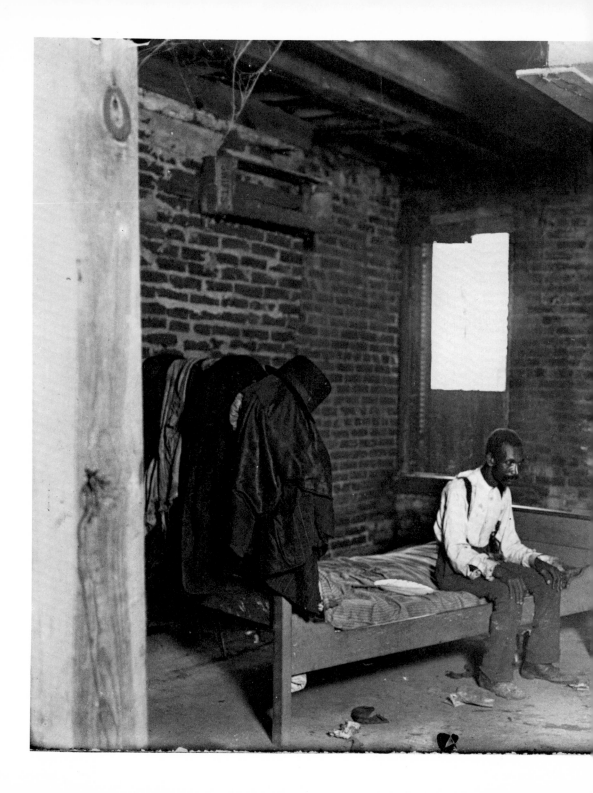

Slum Negro dying of tuberculosis.
Tenement cellar, Washington, D.C., 1908

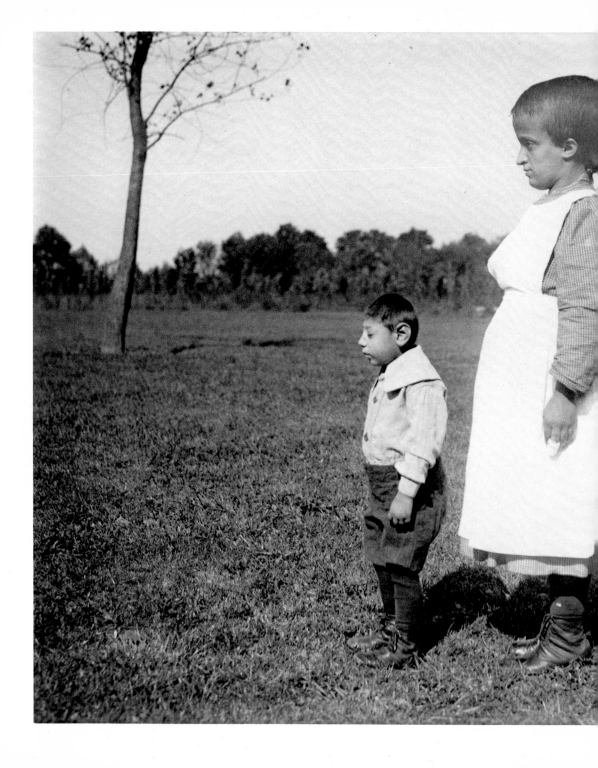

Mental institution, New Jersey, 1924

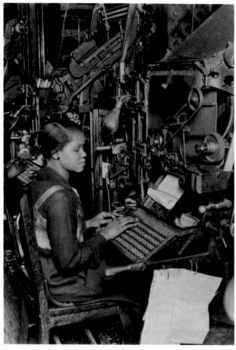

"This Negro girl was an expert linotypist
in a southern publishing house." 1920

Hine often lived on an edge. On the edge of a
proper artistic world and the edge of a more
demanding world of social expression. On the
edge of his community and the edge of being a
loner. We know he lived on the edge of fame, on
the edge of adventure, and on the edge of satis-
faction. When he used two centers of organization
in a photograph, he let our eyes dance back and
forth between them. He set us on edge, made us
move from one center to the other, only to move
back to the first. He showed us how two centers
of life were always the issue, how life would un-
balance, then rebalance between one and the other.

When Hine used these dual centers of organi-
zation he created a controlled movement that was
held in check only to be let loose and drawn back
to its proper and earlier spot all over again. He
used these dual centers with people and with
machines. Who can look at Freddie Hubbard with-
out seeing the other boy's eye upstage him, then
finding Freddie and going right back to look at him.
And who can look at the girl setting type without
accepting her quiet eyes, then seeing the bolts,
fingers, nobs, and the movement that the whole
sequence creates? Who can see her without see-
ing the machine engage her while we move from
one center to the other and become part of the
rhythm they build into a system of satisfaction
and power?

Hine used this eye in the beginning of his life
and at its end. This was the eye that seemed to
catch him as he was shifting sights, as he was
moving toward some new focus. This was his
transitional eye, the eye with which he thought
most as he tried to reconceive of the expectations
of the early part of the century.

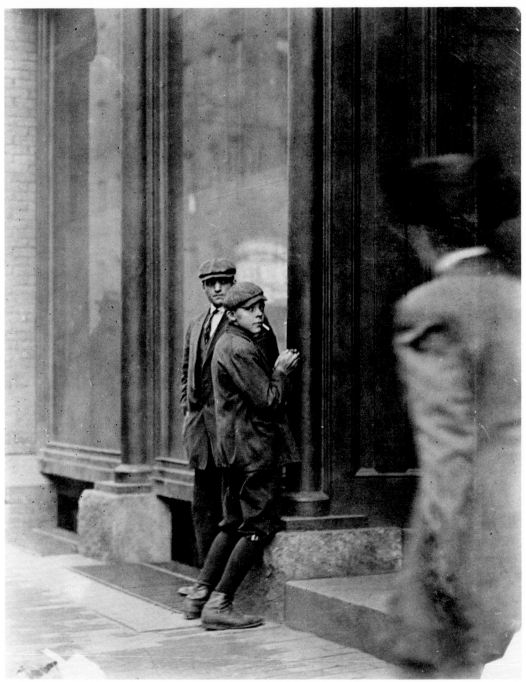

Freddie Reed, fourteen years old,
Springfield, Massachusetts, 1910

And then there were those great groups that Hine flung up along hillsides and out into valleys. Hine let groups proliferate, spill out and regenerate, and form ever-greater numbers. Sometimes they rode on top of boxcars; sometimes they grew out of a smile that moved from one face to the other and finally broke out into a happy new profusion. Hine kept creating larger and newer patterns with people and the ways they lived.

We know that the best artistic structures fill up with the years, that new years and new growth add new dimensions to an earlier conceived, more nascent expression, that new dimensions in life create new patterns and excitement in the already completed artistic expression. We also know that this is a test of artistic expression; we think any good art work should take on more life as the years go by.

Hine's photographs do this, partly because the power of the Direct Eye increases, but also because the movement that his large groups create sets off more furious patterns in its structure today. Our eyes more swiftly follow the kids scrambling up the boxcars. We fall further into the pattern of an industrial town. We dip more wondrously into a town's valley. We try to locate the key to the movement which keeps on increasing. As if the new lyrical patterns could unearth more, we increase the directions and pace, adding new layers to the voluminously lyrical patterns we already follow.

Hine laid bare the range of what people would later see. Not consciously. He wasn't clairvoyant. It was rather that he saw the range of human possibility spread itself out. He showed us the barest, the minimal but clearly complex organization of life that people created with the tools they used and the ways they lived. He showed us the skeleton of what was—not the skeleton of a person, but the skeleton of an organization and far-flung groups of people who all meant something to one another.

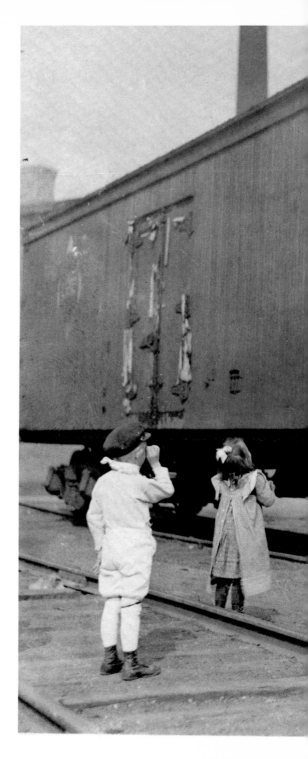

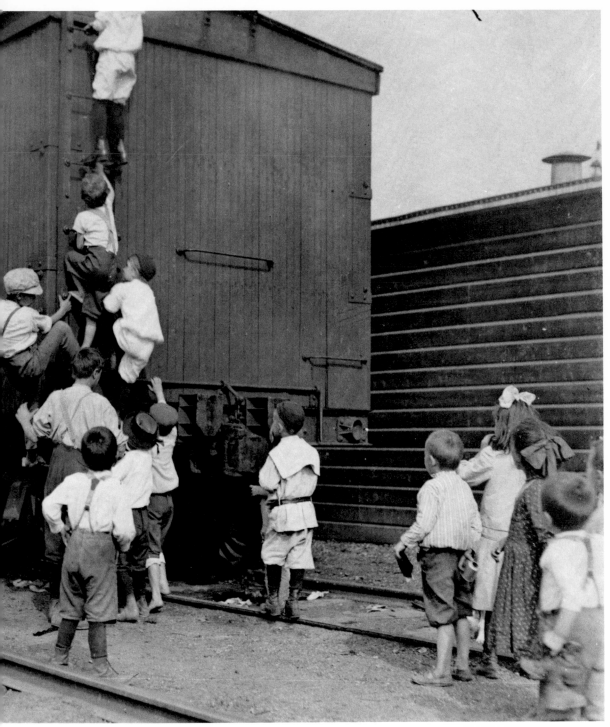

New York City, ca. 1910

All the more interesting, then, for us to realize that he was basically a quiet, "shy" person who often moved off on his own and was rarely seen with more than one other person. Many of his older neighbors in Hastings don't remember him well, reaching back as they speak and hanging onto some nebulous thought that "maybe he was part of that artists' community up on Edgar's Lane. You know," they add somewhat proudly, "that Locust Hill development." Just faintly aware that he came to be well known, they can only put him into a dim glow of life. It is as if he wasn't really a part of that community, even though he nourished himself on it.

But Hine eventually made himself a part of that community and of every community he photographed. His community was the multiplicity of people, expressions, and forms. The ties that made that multiplicity became a meaningful whole. Hine's community rolled out into landscapes, ran down to the Hudson, clambered up boxcars, and moved into activity that spelled out a person's reach for expression. Hine's community was the minimal structure he could find existing below the surface, the minimal structure with all the ties holding it together. His communities were filled with movement. They've only become more filled since.

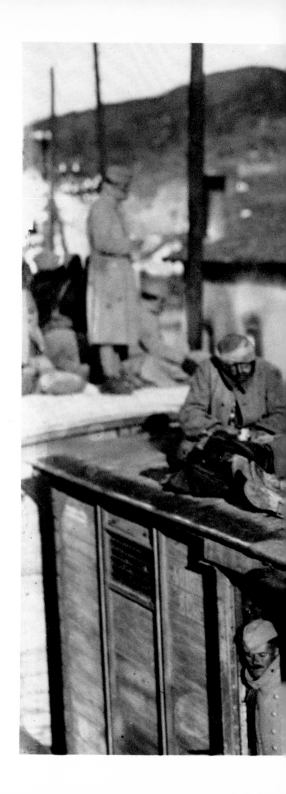

American Red Cross Survey Mission,
France, 1918–1919

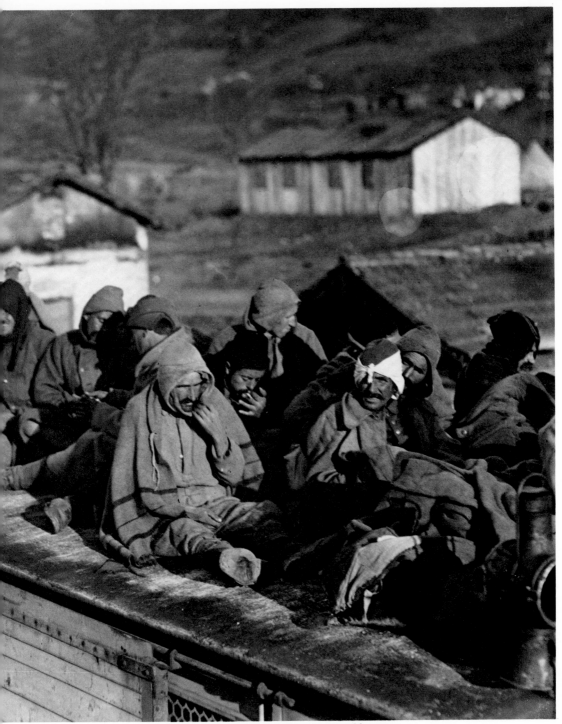

Refugees returning home on top of boxcars,
Strumitza, Serbia, 1918

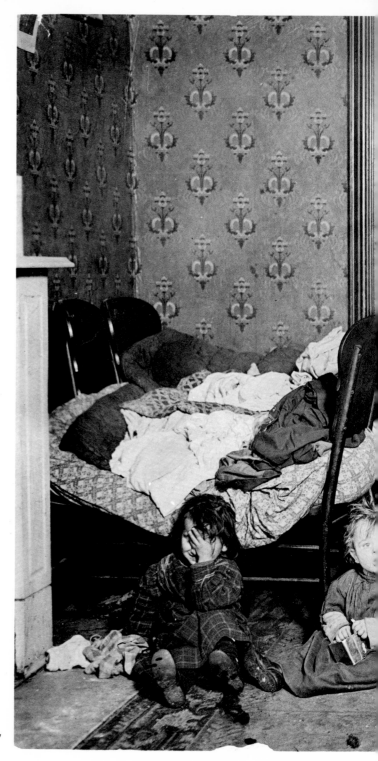

One of Hull House's neighboring families,
Chicago, 1910

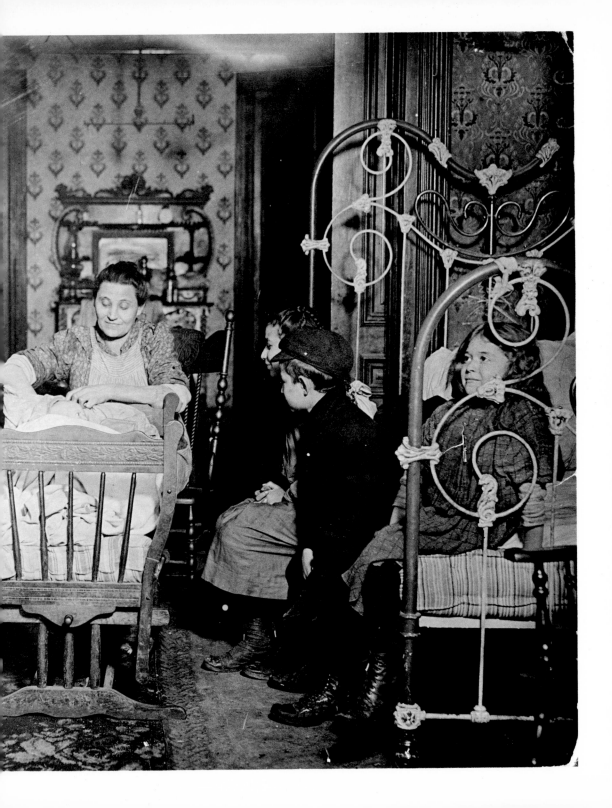

No wonder he saw Americans creating new life. By the 1920s the machine looked out upon the world that Americans had formerly managed. With its own center and system of organization, it gathered all the life about. The instrument panel put Mr. Frank's thumb and his expression into a coherent whole. The generator's eye organized the pattern of its setting and the man around it in the same way that a boy's eye had earlier organized the graffiti and his hair around it. A person became part of the machine's pattern in the same way that a bolt and a nut did. Arm or bolt, face or lever, it didn't matter. All fed the machine's central position equally. One could just as well replace the other. People became links in the process of production, part of the pattern that was to take over the new national focus. The photograph's movement incorporated the human and the mechanical, all of the movement revolving around a machine's eye.

When Hine saw the Eye of the Machine he most often saw it confronting life in the same way the Direct Eye had earlier. Making the machine's eye the center of his focus, Hine saw it replace the Direct Eye he had formerly seen emanating from a person. The machine's eye became the new Social Eye, the new direct way of looking at the world.

Hine even made it serve the same structural needs that the earlier Social Eye had. From the information accompanying each photograph we learn of a machine's horsepower, the tonnage it pulled, the rails it rode along, and whatever other specifics we need to further understand its place. Where Hine formerly had told us about the hours that children worked in mines, now he was telling us about the links in the chains and the railroad ties that hauled coal to the outside world, about the specific details that gave credence to the new major and central focus of American life. In the same way we used the information about Freddie Hubbard to make him come off the page, now we used the information about a rail car to make it stand out as a particular force in the great new dream of American life!

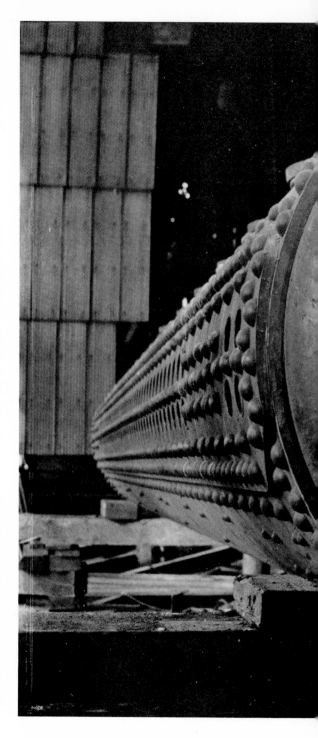

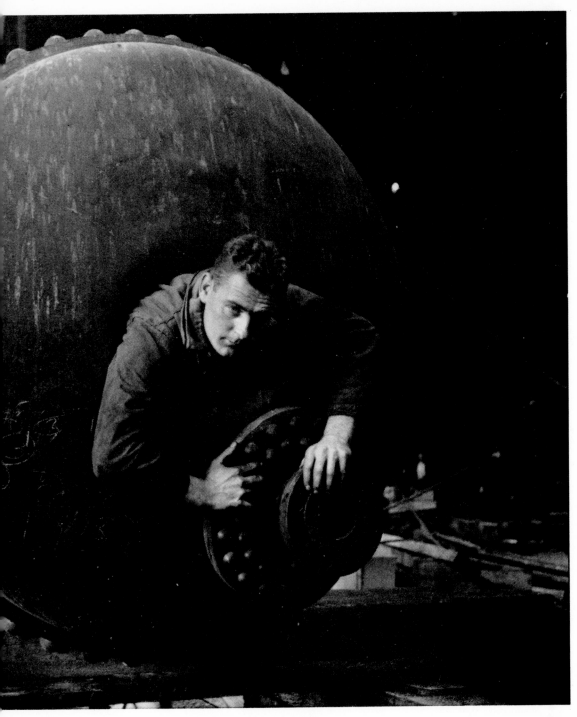

Boilermaker, ca. 1929

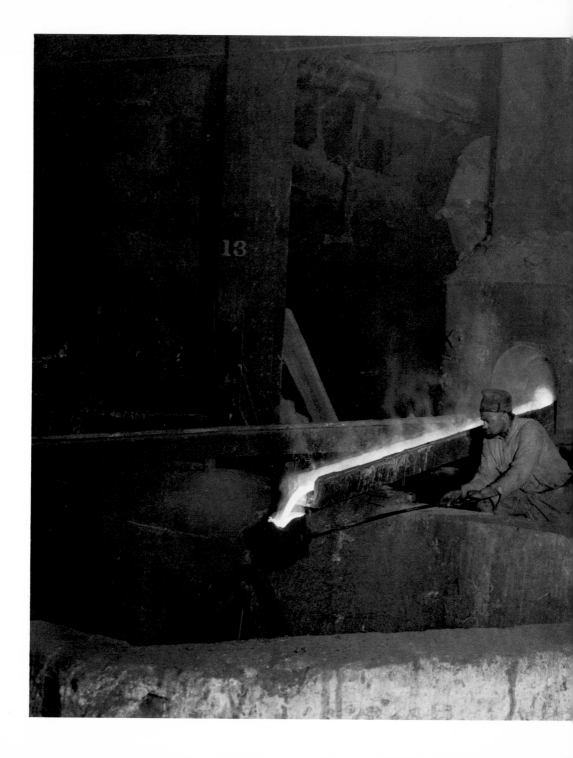

Baldwin Locomotive Works,
Eddystone, Pennsylvania, 1937

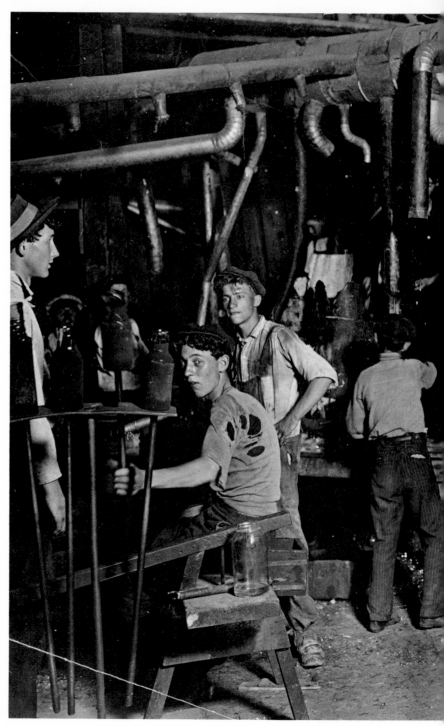

Indiana glass works, 1909

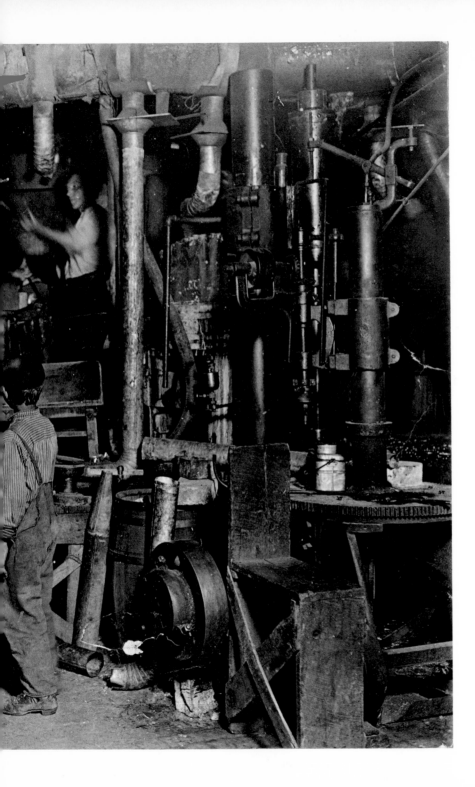

To praise or condemn Hine for this is out of the question. He saw it. Hine's vision followed the eyes that he saw Americans using in their search for human fulfillment. Through them, we see how Americans transferred their early hopes for fulfillment from themselves to the machines they used. What we don't like about it, of course, is the fact that it leaves us upended. We know the machine's dreams didn't fulfill themselves, that we didn't make the machine produce the life its dreams seemed to promise. We also don't like the simple lines of conflict and streams of mastery that many of these photographs suggest. They seem to say that we relinquished power too easily, that we gave up rather than make these machines produce the dreams we were sure lay inside their patterns and design. We seem to be left without any power. Empty.

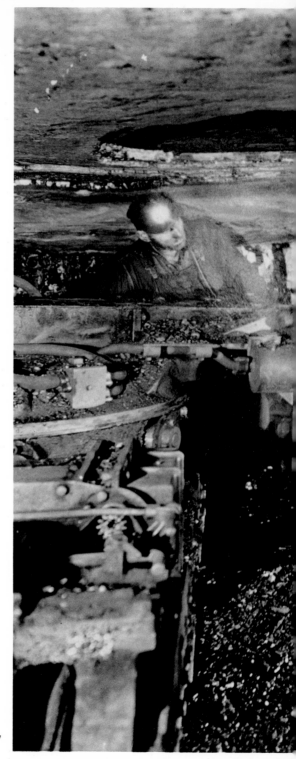

Jeffrey Ancshear.
Machine undercutting a new face in a mine, 1937

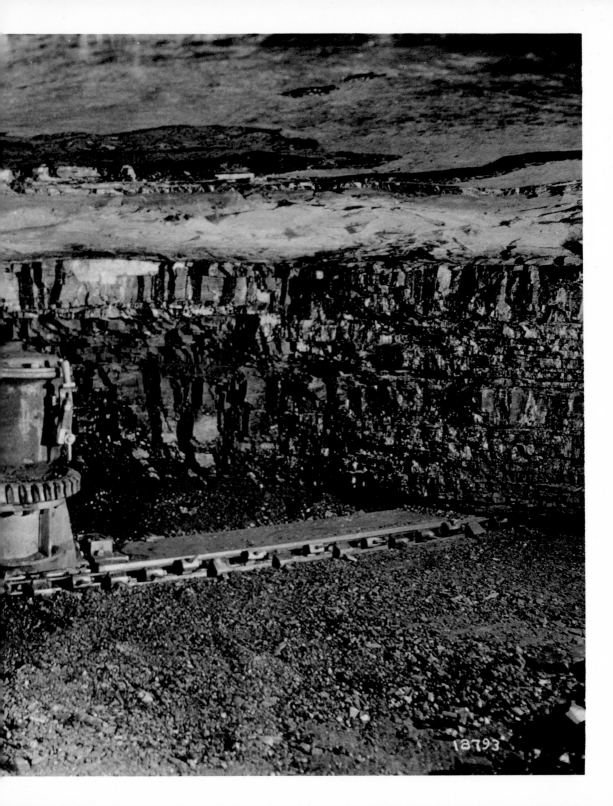

18793

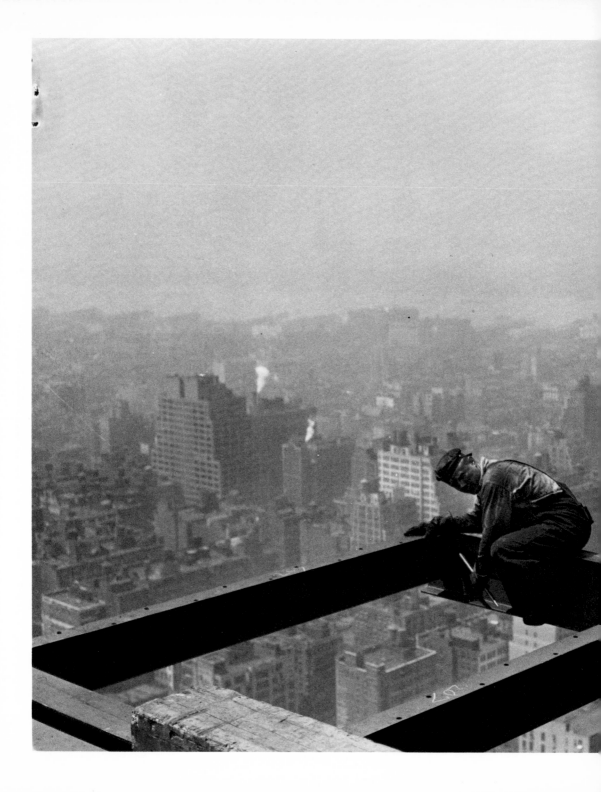

Steelworker,
Empire State Building, New York City, 1931

EXHIBITIONS

1920
Civic Art Club, New York City

National Arts Club, New York City

Woman's Club, Hastings-on-Hudson,
New York

1931
Yonkers Museum, Yonkers, New York

Des Moines Fine Arts Association Gallery,
Des Moines, Iowa

1939
Riverside Museum, New York City

1967
"Lewis W. Hine: A Traveling Exhibition,"
George Eastman House, Rochester,
New York

1969
"Lewis W. Hine:
A Concerned Photographer,"
Riverside Museum, New York City

"The Concerned Photographer"
(one of six one-man shows), circulating
in Israel, Italy, Switzerland, England, and
Czechoslovakia, under the auspices of
the International Fund for Concerned
Photography, Inc.

1970
"Prints from the Collection of
The National Committee on Employment
of Youth," Witkin Gallery, New York City

831 Gallery, Birmingham, Michigan

1971
Focus Gallery, San Francisco, California
Latent Image Gallery, Houston, Texas

1972
Stanford University Museum of Art,
Stanford, California

Friends of Photography Sunset Center,
Carmel, California

1973
Witkin Gallery, New York City
Lunn Gallery, Washington, D.C.

CHRONOLOGY

1874
Born Oshkosh, Wisconsin, September 26

1898
Taught at Oshkosh Normal, encountered
social reform movements while attending
University of Chicago

1901
Moved to New York, joined faculty at the
Ethical Culture School, studied sociology
at Columbia University and New York
University

1905
Began first documentary series on
immigrants at Ellis Island

1908
Resigned from teaching, joined staff of
Charities and Commons (later *Survey*),
did photographic surveys of social
conditions. Became photographer for
National Child Labor Committee—his
pictures used to dramatize tragedy of
child labor

1918-1919
Sent to Europe by the American Red Cross
to record its war work. Recorded effects
of war upon people in the Balkans

1919-1920
Returned to United States.
Did work for *Survey* and *Survey Graphic*,
continued work for National Child Labor
Committee, photographed men at work in
various industrial settings

1932
Published book, *Men at Work*,
which included documentation of
construction of Empire State Building

1933
Documented TVA project for Red Cross,
state and federal agencies; covered
emergency relief, rural nursing, other
health programs

1936
Became photographer for National
Research Project of WPA

1940
Died, Hastings-on-Hudson,
New York, November 3

BOOKS

Boyhood and Lawlessness,
in the "West Side Studies" series under
the direction of Pauline Goldmark,
Russell Sage Foundation

"The Pittsburgh Survey," series
edited by Paul U. Kellogg, Charities
Publication Committee:
Vol. 1. *The Pittsburgh District Symposium*
text by John R. Commons,
Robert A. Woods, Florence Kelley,
Charles Mulford Robinson, et al.
Vol. 2. *The Steel Workers,*
text by John A. Fitch
Vol. 3. *Homestead: The Households of a
Steel Town,*
text by Margaret F. Byington
Vol. 4. *Women and the Trades,*
text by Elizabeth Beardly Butler
Vol. 5. *Work Accidents and the Law,*
text by Crystal Eastman
Vol. 6. *Pittsburgh: The Gist of the Survey,*
text by Paul U. Kellogg

Neglected Neighbors in the National Capital
text by Charles F. Weller
Philadelphia: The John C. Wonston Co., 1...

*Street-Land, Its Little People and
Big Problems,*
text by Philip Davis assisted by
Grace Kroll
Boston: Small, Maynard, and
Company, Inc., 1915

A Seasonal Industry (a study of the
millinery trade in New York),
text by Mary Van Kleeck
New York: Russell Sage Foundation, 191...

Rural Child Welfare
National Child Labor Committee, under
direction of Ed Clopper
New York: Macmillan, 1922

Empire State: A History
New York: Empire State Inc., 1931

Men at Work,
text and photos by Lewis W. Hine
New York: Macmillan, 1932

Lewis W. Hine Portfolio,
with introduction by Thomas F. Barrow
Rochester: George Eastman House, 1970
Twelve letterpress plates in portfolio
reproducing images from original glass
plate negatives in the museum's negative
archive

*Lewis W. Hine and the American Social
Conscience,*
by Judith Mara Gutman
New York: Walker and Company, 1967.
This book contains the definitive
bibliography on Lewis Hine

ARTICLES

1920
"Workers Relation to Industry Shown in
Photographic Survey,"
New York Post, October 28

"Treating Labor Artistically,"
Literary Digest, December 4

1926
"The Photo-Interpreters,"
Mentor, Vol. 14

1930
"Through the Threads,"
by Sidney Blumenthal,
American Magazine of Art, August

1931
"Lewis W. Hine," by Beaumont Newhall,
Parnassus, March

American Magazine, May

"Former Oshkonian's Skill with Camera Is
Told by Woman Who Once Lived Here,"
Oshkosh Daily Northwestern, May 8

"Sky Boys Who Rode the Ball,"
Literary Digest, May 23

"Men and the Skyscraper," by
Lester Jenkins,
The Commercial Photographer, August

"A Generation Re-Discovered Through
Camera Shots," by Elizabeth McCausland,
The Springfield Sunday Union and
Republican, September 11

"Portrait of a Photographer,"
by Elizabeth McCausland,
Survey Graphic, October

"Lewis W. Hine," by Beaumont Newhall,
Magazine of Art, November

1939
"Boswell of Ellis Island,"
by Elizabeth McCausland,
U.S. Camera, January—February

"Portrait of Lewis Hine," by Robert Marks,
Coronet, February

1941
"Railroad Cabman," U.S. Camera Annual

1942
"Railroad Engineer," U.S. Camera Annual

1950
"Early Photographs by Lewis W. Hine,"
American Photography, October

1957
"Lewis W. Hine," by Robert Doty,
Image, May

1966
"They Led Child Labor Crusade,"
Milwaukee Journal, September 21

PERMANENT PUBLIC COLLECTIONS

George Eastman House, Rochester,
New York

Library of Congress, Washington, D.C.

American Red Cross Headquarters,
Washington, D.C.

Prints and Photographs Division,
National Archives, Washington, D.C.

University of Minnesota Social Welfare
History Archives Center, St. Paul,
Minnesota

National Committee on Employment of
Youth, New York City

Avery Library, Columbia University
School of Architecture, New York City

Picture Service Collection, New York
Public Library, New York City

Hine Collection, Local History and
Genealogy Division Room, New York
Public Library, New York City

Ewing Galloway, New York City

Community Service Society,
New York City

International Ladies Garment Workers
Union, New York City

Amalgamated Clothing Workers,
New York City

Ethical Culture Schools, New York City

CONTRIBUTIONS TO PERIODICALS

1906
Elementary School Teacher

1907
World Today

1908-1909
Craftsman

Education

Charities and Commons

1908-1929
National Child Labor Committee Pamphlets
and Bulletins

1909-1929
Survey (formerly Charities and Commons)

1929-1933
Survey Graphic

CATALOGUES

1939
Lewis W. Hine Retrospective Exhibition,
New York, Riverside Museum

CAMERA TECHNIQUE

When he started photographing in 1903,
Hine used a 5 x 7 view camera,
magnesium powder for light flashes, a
rapid rectilinear lens, and glass plate.
During World War I he used film and
glass plates, the film 4 x 5, the glass
plates both 4 x 5 and 5 x 7. His Empire
State series was the first major series he
did with safety film—all 4 x 5. By 1920
he seemed to have turned exclusively to
a 4 x 5 graflex, and for the rest of his
life worked out an adapter for it using
either an eight- or five-inch lens, giving
him medium-long and medium-short
focus. He rarely used filters

Photograph Credits

Pages 13, 14, 19, 20, 24, 26, 30, 33, 36, 39, 46, 48, 52, 56, 57, 58, 59, 60, 62, 64, 66, 68, 72, 80. Courtesy of the George Eastman House, Rochester, New York.

Pages 18, 40, 44, 70, and cover. From the collection of Mickey Pallas, the Center for Photographic Arts, Ltd., Chicago. Courtesy of the George Eastman House, Rochester, New York.

Pages 9, 10, 52. Courtesy of Ewing Galloway, New York.

Pages 22, 29, 50, 54, 55, 65, 68, 76. Courtesy of the Library of Congress, Prints and Photographs Division, Washington, D.C.

Pages 12, 32, 34, 35. Courtesy of the Metropolitan Museum of Art, New York. Gift of Clarence McK. Lewis, 1954.

Page 28. Courtesy of the Metropolitan Museum of Art, New York. Gift of Phyllis Dearborn Massar, 1970.

Page 15. Courtesy of the Metropolitan Museum of Art, New York. Gift of Mr. and Mrs. Wolfgang Pulverman, 1969.

Pages 43, 74, 78. Courtesy of the National Archives, Washington, D.C.

Page 11. Courtesy of the New York Public Library, New York, Lewis W. Hine Collection, Local History and Genealogy Division, Astor, Lenox and Tilden Foundations.